MICHELANG.
MERIGI
DA
CARAVAGGIO

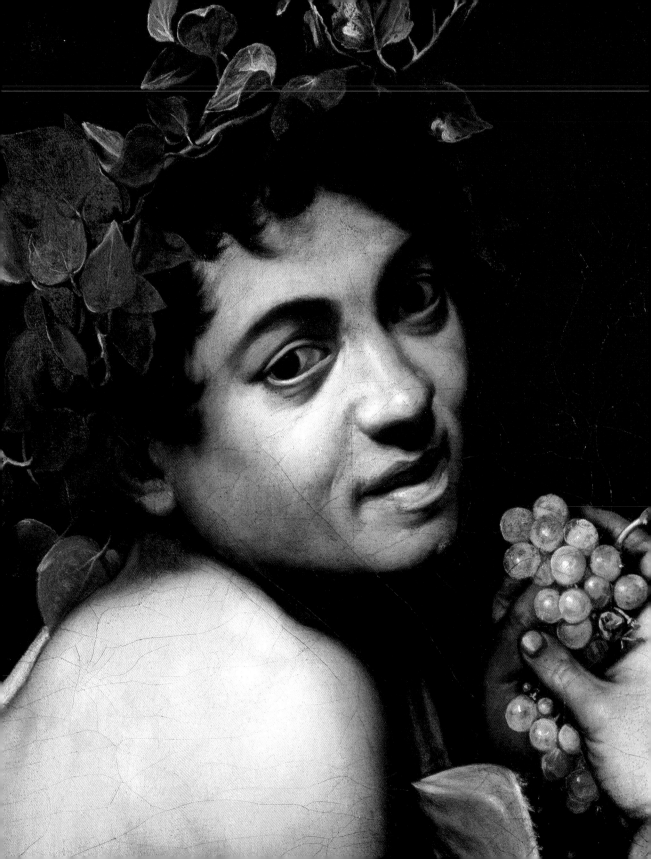

Gilles Lambert

CARAVAGGIO

1571–1610

Edited by Gilles Néret

TASCHEN

KÖLN LONDON LOS ANGELES MADRID PARIS TOKYO

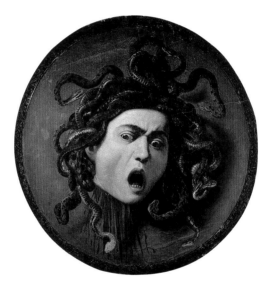

Head of the Medusa, c. 1598–1599
Oil on canvas mounted on a poplar shield, 60 x 55 cm
Florence, Galleria degli Uffizi

To stay informed about upcoming
TASCHEN titles, please request
our magazine at www.taschen.com
or write to TASCHEN America,
6671 Sunset Boulevard,
Suite 1508, USA–Los Angeles,
CA 90028, Fax: +1-323-463 4442.
We will be happy to send you a free copy
of our magazine which is filled
with information about all of our books.

© 2004 TASCHEN GmbH
Hohenzollernring 53, D–50672 Köln
www.taschen.com
Original edition: © 2000 Benedikt Taschen
Verlag GmbH
Text by Gilles Lambert, Paris
English translation by Chris Miller, Oxford
Cover design by Angelika Taschen, Cologne

Printed in Germany
ISBN 3–8228–6305–X
GB

Contents

6

The Artist as Outlaw

18

A Revolutionary on the Highroad 1571–1592

46

The Master of Darkness 1592–1606

80

The Peregrine Years 1606–1610

92

Life and Work

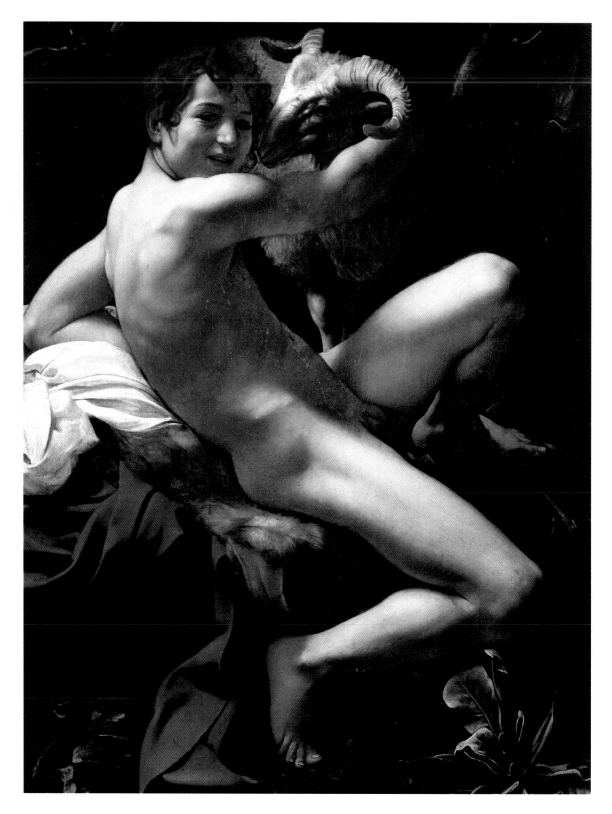

The Artist as Outlaw

His life was sulphurous and his painting scandalous. Michelangelo Merisi, known as Caravaggio (the name of his native village near Bergamo), was a downright villain. Other artists had had brushes with justice before him: Duccio was a drunkard and a brawler. The quarrelsome Perugino was involved in street fights, and, as a young man, spent time in prison. And the sculptor and goldsmith Benvenuto Cellini, accused of embezzlement, murder and sodomy, was incarcerated in the Castel Sant'Angelo. Caravaggio was repeatedly arrested and imprisoned. He confessed to the murder of an opponent at tennis whom he suspected of cheating, and he was rumoured to have committed other crimes. He was a painter of genius, who worked with extraordinary speed, painting directly onto the canvas without even sketching out the main figures. His powerful patrons found it increasingly difficult to extract him from the prison cells in which he so often languished. Caravaggio risked his life escaping from his last prison, on the island of Malta, as Cellini had done escaping from Castel Sant'Angelo. The evidence suggests that he was sentenced for what we would now term paedophilia. He died, a persecuted outlaw, on a beach south of Rome, perhaps, like the film-director Pier Paolo Pasolini, a victim of murder.

Caravaggio is the most mysterious and perhaps the most revolutionary painter in the history of art. In Rome, thirty-four years after the death of Michelangelo, he originated a violent reaction to the Mannerism of his elders, which he regarded as constrained, mawkish, and academic. He created a new language of theatrical realism, choosing his models in the streets. In every subject he selected the most dramatic instant, even for the most sacred themes, like the Death of the Virgin, which he painted, almost without precedent, as a night-scene. The primacy of nature and truth was his watchword.

In painting, Caravaggio is the apotheosis of what was later called the "Baroque". On the cusp of the 16th and 17th centuries, the Baroque was a period of fury, ecstasy and excess. The Council of Trent defined the principles of the Counter-Reformation; Popes and Jesuits countered the austerity of Luther and Calvin, who had banished paintings and sculptures from the church, with a great outpouring of imagery, ornament, colours, contrasts and theatrical decors, fit to dazzle the believer and reaffirm the predominance of Rome. Claudio Monteverdi had just invented the operatic form. The work of Caravaggio entered and exacerbated this tempestuous atmosphere. Every one of his works raised a scandal, and he made many enemies. Nicolas Poussin, who arrived in Rome shortly after Caravaggio's death, observed: "He came to destroy painting".

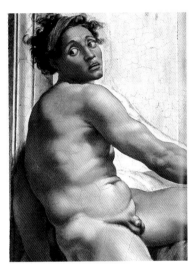

Michelangelo
Ignudi, 1509
Detail of the Sixtine Chapel fresco, near the
Flood and above the *Eritrean Sibyl*

PAGE 6:
Saint John the Baptist, 1599–1600
Oil on canvas, 129 x 94 cm
Rome, Musei Capotilini, Pinacoteca
Capitolina

Like Caravaggio, his illustrious forebear
Michelangelo frequently painted young men,
his models and lovers. But his *Ignudi* are the
expression of beauty born of God's hand,
whereas those of Caravaggio are invariably
somewhat equivocal.

Boy with Basket of Fruit, c. 1593–1594
Oil on canvas, 70 x 67 cm
Rome, Galleria Borghese

Boy with a Vase of Roses (copy?), 1593–1594
Oil on canvas, 67.3 x 51.8 cm
Atlanta (Georgia), Art Association Galleries
of Atlanta, The High Museum of Art

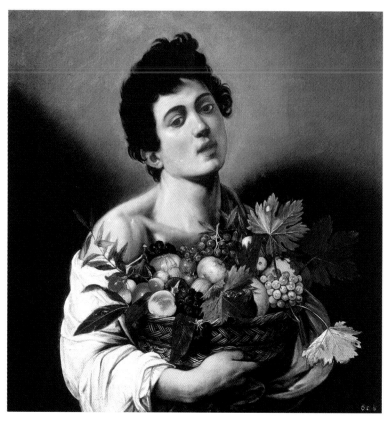

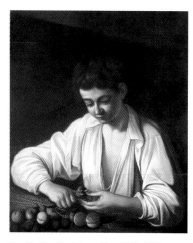

Boy Peeling Fruit (copy?), c. 1593–1594
Oil on canvas, 75.5 x 64.4 cm
Rome, Private collection

PAGE 9:
Detail of *Boy with Basket of Fruit*

Not until 1596, in the *Repentant Magdalene* (ill. p. 28), did Caravaggio paint his first portrait of a woman.

The shockwaves produced by his work were powerful and long lasting, and his reputation did not survive them. His name was forgotten, and he had to wait three hundred years for his reputation to be vindicated. His name began to reappear in the late 19th century, but it was not until the 1920s that the work of the art critic Roberto Longhi again brought his name before the public. Only then did his true stature emerge. For Longhi, Caravaggio's influence extended throughout the 17th century (notably in the work of Rembrandt) and well beyond, as far as Delacroix, Géricault (who copied Caravaggio's *Entombment* before painting the *Raft of the Medusa;* ill. p. 63), Courbet and Manet. "With the exception of Michelangelo, no other Italian painter exercised so great an influence," wrote that hostile witness, the American critic Bernard Berenson, who had little time for Caravaggio and deemed him "incongruous". "After him, painting could never be the same again. His revolution was a profound and irreversible modification of the emotional and intellectual relation between the artist and his subject," declared Giuliano Briganti. André Berne-Joffroy, Paul Valéry's secretary, put it in a nutshell: "In the aftermath of the Renaissance, what begins in the work of Caravaggio is, quite simply, modern painting".

During his lifetime, Caravaggio was deemed unacceptably provocative, and death offered no reprieve. His body was never found, and there were those who claimed that he had organised his own disappearance, and simulated death in order to evade prosecution. His first biographer, Giovanni

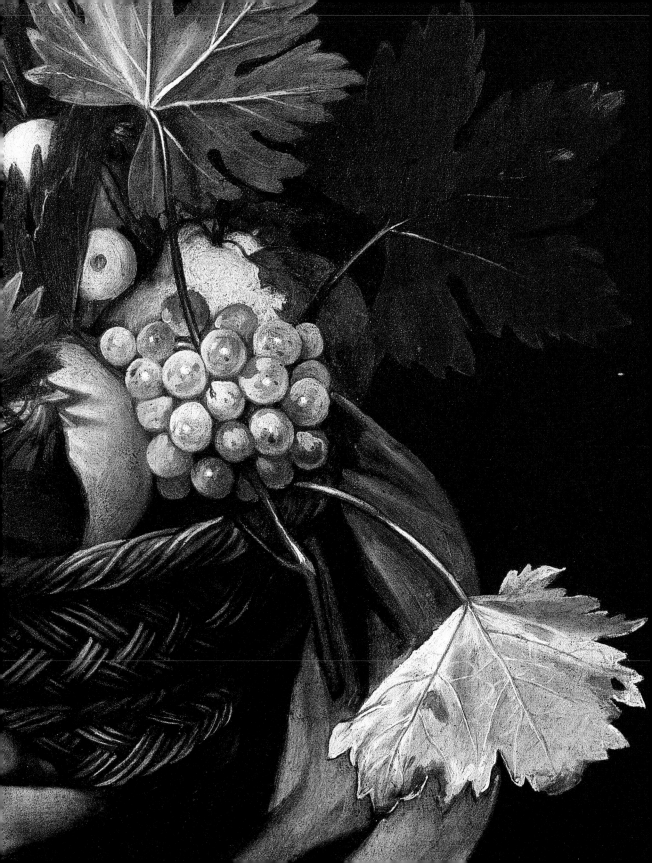

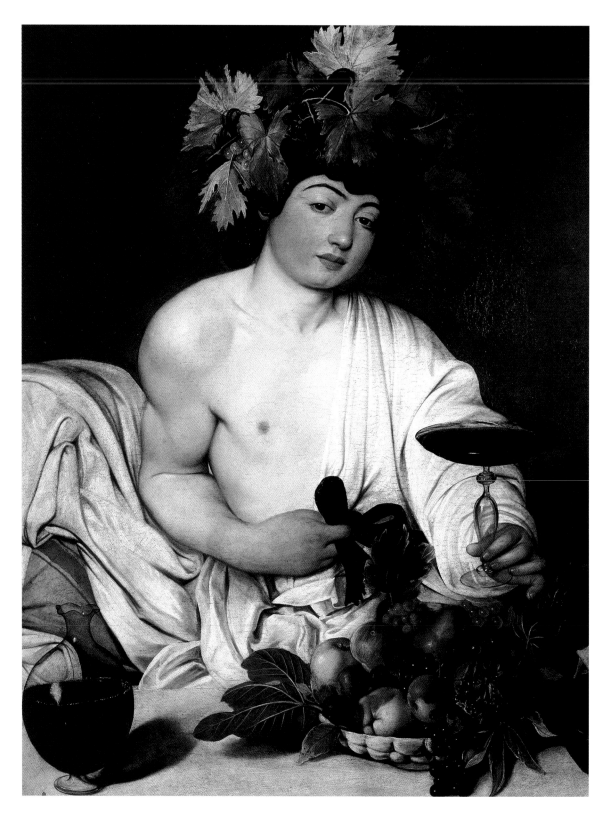

Baglione, detested him, and did not spare his memory. Rumours spread; he was accused of plagiary and theft. His works were reattributed and assigned to his more reassuring rivals, respected academicians of high repute. They included Cavaliere d'Arpino, for whom Caravaggio worked when he arrived in Rome, Guido Reni, who resembled him so little (legend has it that Reni died a virgin), Guercino, Domenichino, Giuseppino, Albani, and even Ribera and Zurburán. In return, works were falsely attributed to him. As Berenson describes it, "any work of strong chiaroscuro presenting huge, obese and vulgar protagonists, sacrilegiously posed as Christ or the Apostles, plumed heads, hordes of men and women wearing an ignoble and drunken aspect, young scallywags playing dice or cheating" was "a Caravaggio".

The few historians who cite his name – one such was Joachim Winckelmann in 1750 – gave no indication of his importance. He who had put the *oscuro* into *chiaroscuro* was himself wreathed in obscurity. He disappeared from lists, chronologies, in short, from the history of art. Luigi Lanzi, whose monumental *Storia pictorica dell'Italia* (1792), was much quarried by Stendhal, could not even spell his name. He appears there as Michelangelo Amerighi or Morigi, and occupies a total of two paragraphs. Stendhal, a great admirer of Guido Reni (whom he considered superior even to Raphael) cites Caravaggio's name just twice in his *Histoire de la Peinture en Italie*, and in his *Promenades dans Rome*, he recommends Domenichino's frescoes at San Luigi dei Francesi rather than Caravaggio's paintings, in which he perceived only "crude but energetic peasants".

Strange as it seems, the Romantics too gave Caravaggio a wide berth. Balzac does not mention him in the *Comédie humaine*, and Théophile Gautier confines himself to remarking "He seems to have lived in caverns or gambling dens" *(Description du Louvre*, 1849). In his famous *Cicerone*

Detail of *Bacchus*

PAGE 10:
Bacchus, c. 1596–1597
Oil on canvas, 95 x 85 cm
Florence, Galleria degli Uffizi

PAGE 12:
Saint Catherine of Alexandria, c. 1598
Oil on canvas, 173 x 133 cm
Madrid, Museo Thyssen–Bornemisza

PAGE 13:
Detail of *Lute Player* (p. 14)

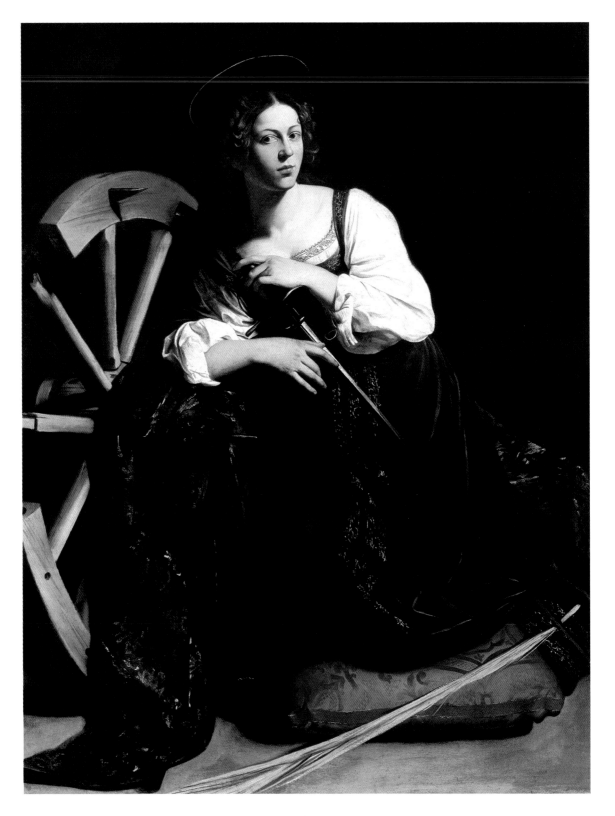

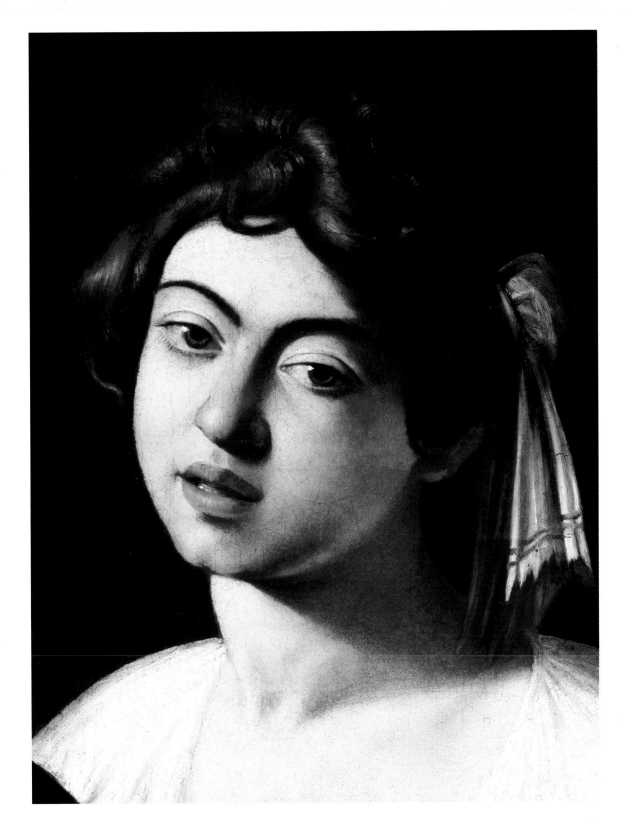

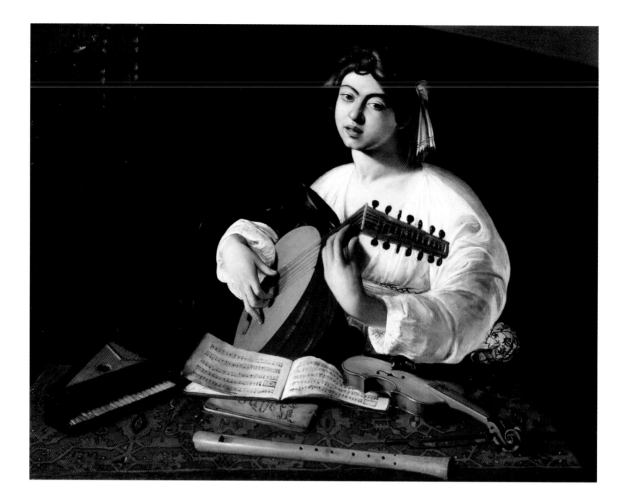

Lute Player, 1596–1597
Oil on canvas, 100 x 126.5 cm
New York, Private collection loaned to
Metropolitan Museum of Art

(1855), the standard guide-book for the enlightened 19th-century traveller in Italy, Jacob Burckhardt deems the *Martyrdom of Saint Matthew* "all but ridiculous" and speaks of "poverty and monotony". Zola, in his novel *Rome*, praises the Carracci frescoes in the Palazzo Farnese, but fails to mention Caravaggio. In his *Voyage en Italie*, Hippolyte Taine visits Santa Maria del Popolo, where he admires "a charming *Saint Michael* by Guido Reni, a consummately fine *Saint Francis* by Domenichino", and completely overlooks the *Vocation of Saint Paul*. He did not take the trouble to visit San Luigi dei Francesi, where Caravaggio's masterpieces hang (it is true that the lighting made appreciation all but impossible at that period).

In the wake of this long and unjustified oblivion came spectacular re-discovery and increasingly rapturous approval. Around 1890, while working on the *Catalogue of the Imperial Collections of Austria,* Wolfgang Kallab detected a common style linking several early 17th-century works of controversial authorship. He concentrated on the treatment of light, the quality of brushwork, and on certain particularities that he studied in depth. He put forward the name of Michelangelo Merisi: Caravaggio. At the time, not a single signed painting was known; even today, only one is known. Little was known of this *peintre maudit*. But the hypothesis gradually came to be

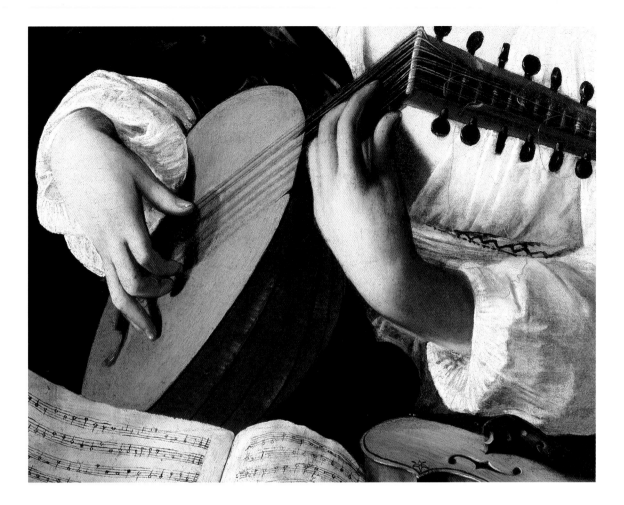

Detail of *Lute Player* (ill. p.14)

accepted. Specialists such as Hermann Voss, Denis Mahon, M. Marangoni, and Lionello Venturi began to define the corpus. The discovery of archive documents in Rome, Naples and Malta gave the work of scholars a new impetus. In 1920, Robert Longhi nailed his colours to the mast: "People speak of Michelangelo de Caravaggio, calling him now a master of shadow, now a master of light. What has been forgotten is that Ribera, Vermeer, la Tour and Rembrandt could never have existed without him. And the art of Delacroix, Courbet, and Manet would have been utterly different". And thus Caravaggio began a second career as an old master.

Since then, his reputation and influence have grown incessantly. Shortly after the Second World War, in the Palazzo Reale in Milan, an exhibition entitled "Mostra del Caravaggio e dei Caravaggeschi" (Caravaggio and the Caravaggesques) was held. It was conceived by Roberto Longhi, and was a first of its kind; it was also a great popular success. The Baroque had become fashionable. In 1985, the Metropolitan Museum of New York presented "The Age of Caravaggio", which included the recently identified originals of *Concert* and *Victorious Cupid*. Shortly afterwards, "The Century of Caravaggio in French Collections" opened at the Grand Palais in Paris, with the Rouen *Flagellation* at its heart.

PAGE 16:
Victorious Cupid, c. 1602–1603
Oil on canvas, 156 x 113 cm
Berlin, Gemäldegalerie, Staatliche Museen zu Berlin – Stiftung Preussischer Kulturbesitz

PAGE 17:
Self-Portrait as Ill Bacchus, c. 1593–1594
Oil on canvas, 67 x 53 cm
Rome, Galleria Borghese

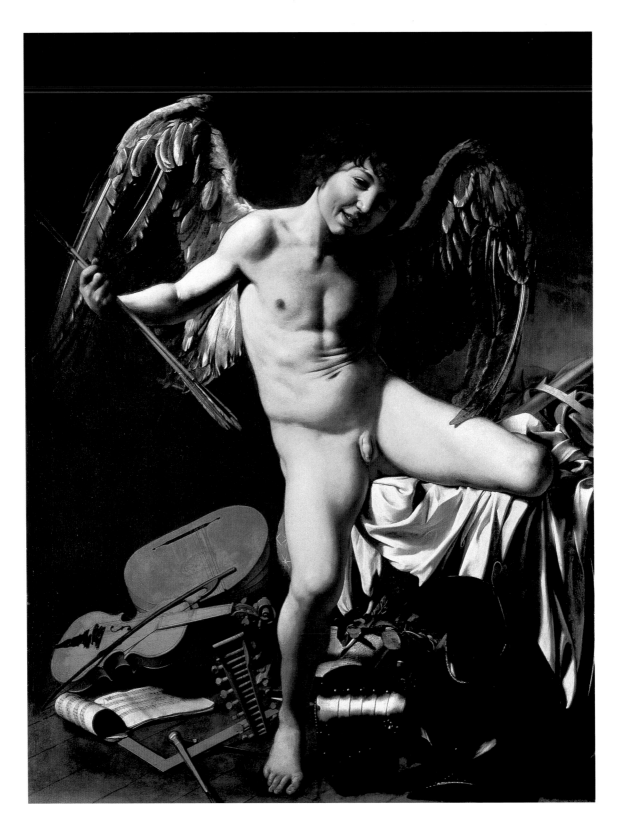

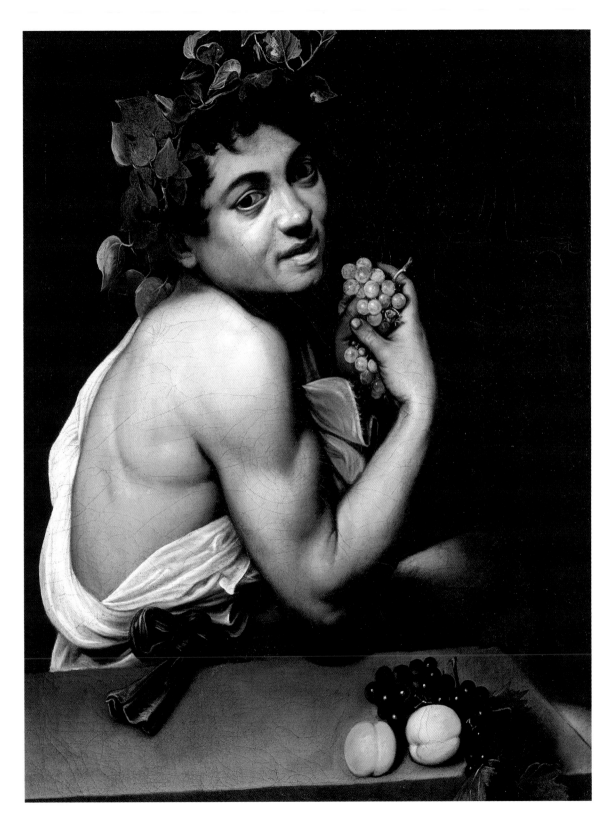

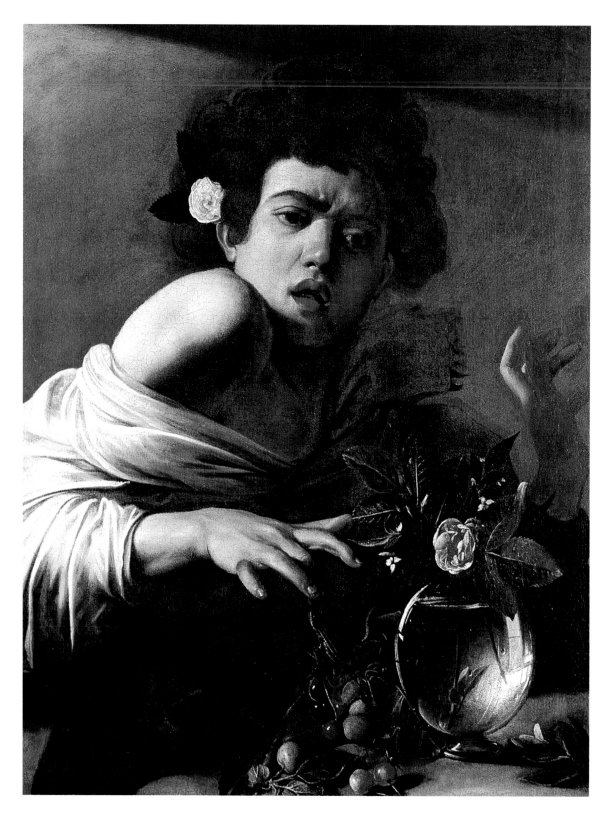

A Revolutionary on the Highroad
1571–1592

Michelangelo Merisi of Caravaggio, a village in the region of Bergamo, had a troubled childhood and adolescence. His date of birth is known to us from the recent discovery of the contract by which he was, in 1694, bound apprentice in the workshop of Simone Peterzano, an established Milanese painter and "pupil of Titian". He was born in September 1571, the year in which, at the Battle of Lepanto, the Ottoman fleet was defeated and Christian dominance of the Mediterranean restored, and a few months before the Saint Bartholomew's Eve massacre in France (August 1572).

During Caravaggio's apprenticeship, Pope Sixtus V, a former swine-herd, ruled over Rome. The Counter-Reformation was in full swing. The Duchy of Milan was dominated by Spain, and was a centre of reaction both religious and artistic. Throughout the rest of Italy, Mannerism prevailed: an academic and rather affected style modelled on the great Roman and Venetian masters. In Lombardy, a freer style had developed, more closely based on reality. It was an early influence in the artistic life of Caravaggio.

His father, Fermo Merisi, was a *magister*, that is, an architect-decorator to the Duke of Milan, the Marquis of Caravaggio, Francesco Sforza I. Caravaggio spent his early years in Milan. In 1576, plague struck the city, and the Duke and his court moved to the Marquisate of Caravaggio. There was no escape, however, for Caravaggio's father and uncle, who both fell victim to the epidemic. His mother brought up her five children in grinding poverty. One of his brothers became a priest, only to be disowned by Caravaggio when, at Rome, the artist was at the height of his fame.

With Francesco Sforza's death, the Marquisate fell to Prince Colonna, and it was almost certainly he who, hearing of the gifts of the young boy from Caravaggio, negotiated a four-year apprenticeship with Simone Peterzano. The protection of the Colonna family was of lasting benefit to Caravaggio, and on one occasion saved his life.

We know little about the activity of Peterzano's studio at the time when Caravaggio was serving his apprenticeship. We know from the *Trattato* (1584) of Giovanni Paolo Lomazzo that Peterzano was reputed for the "lightness and elegance" of his work. His frescoes at the Certosa di Garegnano, near Milan, display a Mannerism tempered with Lombard realism, and a similar impression is given by the *Venus, Cupid and Two Satyrs* (New York, Corsini Collection), in which the treatment of the nudes is reminiscent of the Venetian school. The earliest works of Caravaggio are clearly marked by the influence of the Peterzano.

But other influences also transpire, notably those of the great Masters.

Sofonisba Anguisciola
Portrait of Her Son Asdrubale Bitten by a Crayfish, c. 1554
Drawing, 33.3 x 38.5 cm
Naples, Museo e Gallerie Nazionale di Capodimonte

PAGE 18:
Boy Bitten by a Lizard, c. 1595
Oil on canvas, 65.8 x 52.3 cm
London, National Gallery

In Milan, Leonardo's *Virgin of the Rocks* in San Francesco Grande (ill. p. 35) was much admired for its expressive power. In Bergamo, the work of Lorenzo Lotto enjoyed great prestige. Did Caravaggio visit Venice during or after his apprenticeship? Bernard Berenson believes that he must have done, perceiving the influence of Giorgione, Titian and even of Giovanni Bellini in his early work. Mina Gregori, a specialist of our own day, takes the same view. He undoubtedly studied the works of that master of perspective, Andrea Mantegna, at Vicenza, and his only fresco clearly shows this influence. He also travelled to Mantua, where the Palazzo del Te, with its monumental works by Giulio Romano drew the attention of all lovers of painting.

In Milan itself, a new school had grown up in the wake of the Campi brothers; inspired by everyday reality, it treated light in a completely new fashion. It was perhaps from Girolamo Savoldo that Caravaggio received the revelation of *chiaroscuro*: no, light did not fall inevitably from the sky like a gift from the gods. Other painters of a previous generation, such as Moretto da Brescia, Vincenzo Foppa and Girolamo Romanino had revolted against *la maniera*. In Bologna, the Carracci brothers were engaged in a similar enterprise. At Cremona, where Caravaggio studied the frescoes of Pordenone, the famous Sofonisba Anguisciola, who had, as a young woman, known Michelangelo, interspersed her portraits of enthroned

Basket of Fruit, c. 1598–1599
Oil on canvas, 31 x 47 cm
Milan, Pinacoteca Ambrosiana

Until 1919, this *trompe-l'oeil* painting was thought to be a Dutch work; today, the attribution to Caravaggio is undisputed.

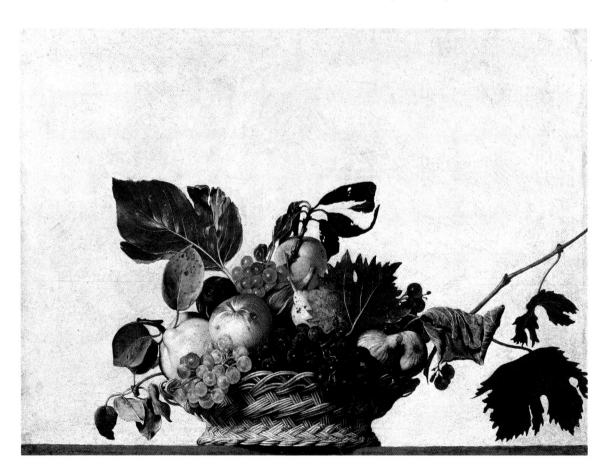

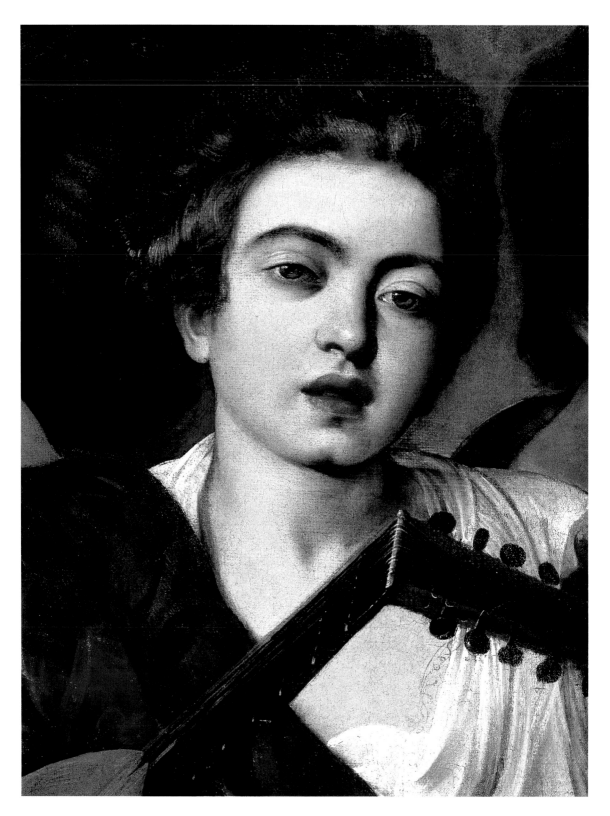

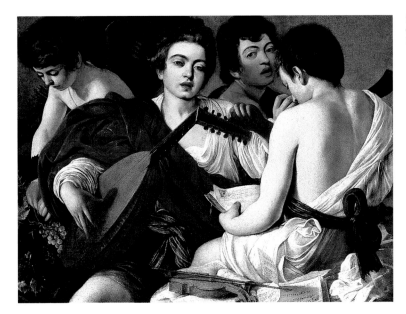

The Musicians, c. 1595–1596
Oil on canvas, 92 x 118.5 cm
New York, Metropolitan Museum of Art

princes with scenes from real life. Anguisciola's chalk and charcoal drawing of her little son being bitten on the finger by a frog (ill. p. 19) imprinted itself on Caravaggio's memory, and became the subject of one of his earliest Rome paintings.

Caravaggio's training as a painter, his emotional life and youthful experiences remain a matter for hypothesis, as does the formation of his style. In Berenson's view, Venice and its great masters were essential components of that style. The influence of the Lombardy school is equally evident. "In Milan," wrote Roberto Longhi, "a group of native or naturalised painters, had opened a sanctuary of simplicity in art… Theirs was a more familiar view of humanity; combined with a sympathy for humble religiosity, a truer and more attentive sense of colour, and more exact representation of shadows – they even painted night scenes – it opened new avenues of painting to the young artist". Caravaggio had learnt a great deal in Peterzano's studio; he was now a master of technique. At eighteen, full of impatience, ambition and the desire to paint, he set off for Rome.

Why Rome? Caravaggio could have settled in Milan or another Lombard city; the patronage of the Colonna family was felt throughout Lombardy, and art was flourishing. He wanted more; he wanted everything. Rome was the cultural and artistic capital of Italy, indeed, of the world.

It was also a city in the throes of transformation. The dome of Saint Peter's, the biggest building in the world, had just been completed, and the construction of great basilicas such as Santa Maria Maggiore and San Giovanni in Laterano had marked the triumph of Christianity. New avenues were being constructed, such as the Via del Corso. The port of Ripetta on the Tiber opened up the city to the world. Sixtus V had called on all the artists of the peninsula – architects, painters, sculptors, engravers and goldsmiths – to come to Rome. Many Lombard artists responded to his appeal, notably the architect Domenico Fontana, who erected the obelisk in the piazza of Saint Peter's, and the painter Cristofero Pomarancio.

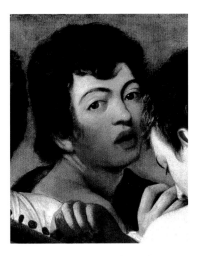

Detail of *The Rusicians:* Self-portrait as singer

PAGE 22:
Detail of *Concert*

PAGES 24–25:
The Fortune Teller, c. 1596–1597
Oil on canvas, 99 x 131 cm
Paris, Musée du Louvre

Anecdote here enters painting: a trusting young man is the victim of a theft. Georges de La Tour returned to this theme (ill. p. 94).

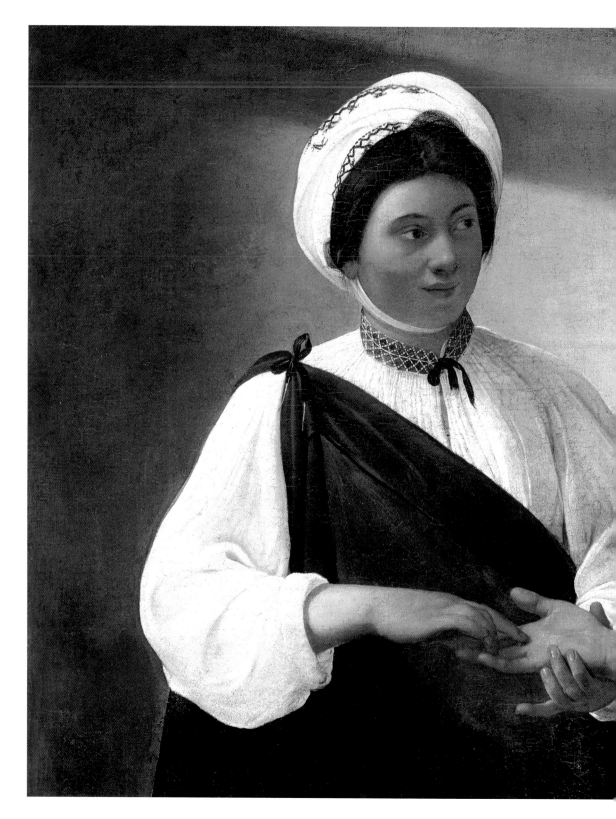

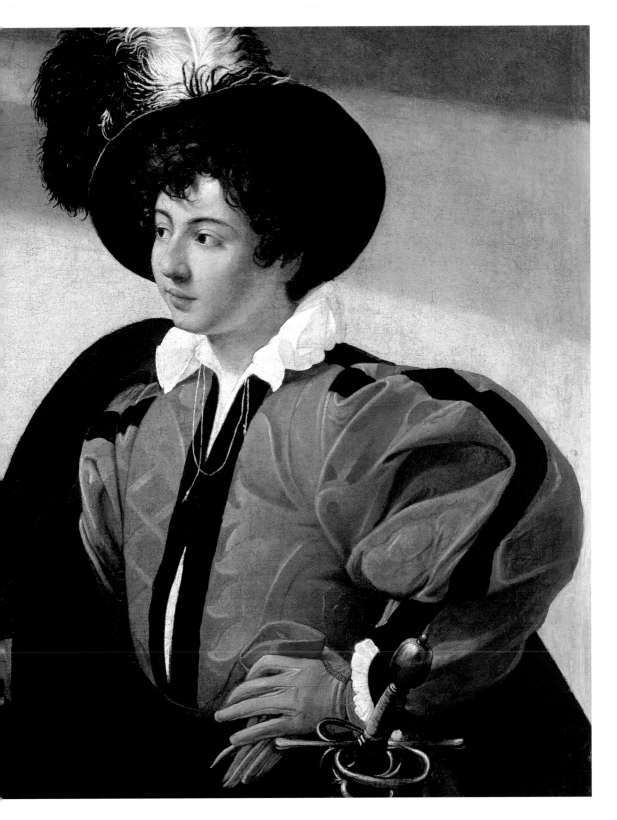

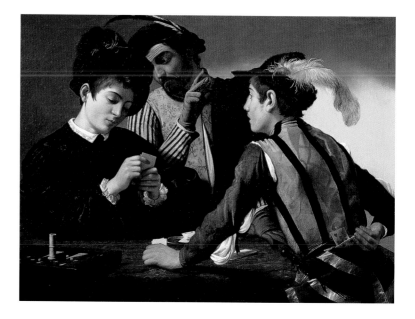

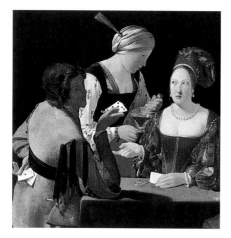

Georges de La Tour
The Cardsharps (detail: the cardsharp with
the ace of diamonds), c. 1630
Oil on canvas, 96 x 155 cm
Paris, Musée du Louvre

PAGE 27:
Detail of *The Cardsharps*

On the road to Rome, Caravaggio no doubt stopped in Parma; there he would have been struck by the *Deposition of the Virgin* painted for the Capuchins by Annibale Carracci, who had already moved to Rome. This is perhaps the source for Caravaggio's famous and scandalous *Death of the Virgin* in the Louvre (ill. p. 73). Probably he also passed through Viterbo, where he would have seen the *Flagellation* by Sebastiano del Piombo (ill. p. 87). In Florence, he must have dwelt on the works of Masaccio in the Cappella Brancacci at Santa Maria del Carmine. Or so we must suppose, for Caravaggio left no notes, and we can accord little trust to his early biographers, who were jealous when not downright hostile.

The roads were very dangerous; gangs of bandits, such as that of the sinister Sciarra, robbed and killed travellers without mercy. Montaigne, thirty years before, ensured a proper escort before travelling to Rome. No one knows what perils Caravaggio passed through; he probably arrived in 1591–1592. No one will ever know which was the pope whose noisy funeral cortege passed him near the Porta del Popolo: the aged Sixtus V, carried off by the plague, Urban VII, who succeeded him for the period of exactly thirteen days, Gregory XIV, who reigned ten months, Innocent IX, who reigned two months, or, most likely, Clement VIII, of the Aldobrandini family.

Caravaggio had no doubt brought with him a number of canvases painted in Peterzano's studio. But their realist style was unfashionable in Rome, where Mannerism and imitation of Michelangelo or Raphael was the order of the day. The artists then in vogue lacked originality and have left little mark on art history: Agnesti, Sciolante, Taddeo Zuccari, Cesare Nebbia, Salviate, Rafaelino di Reggio, and the Cavaliere d'Arpino. The new tendencies finding expression in the work of the Bolognese painter Annibale Carraccci, who had just been chosen to decorate the Farnese Gallery, were treated with suspicion and showed no sign of catching on. Kallab, one of those responsible for the "rediscovery" of Caravaggio, wrote: "Young artists arriving in Rome in the late 16th century were in

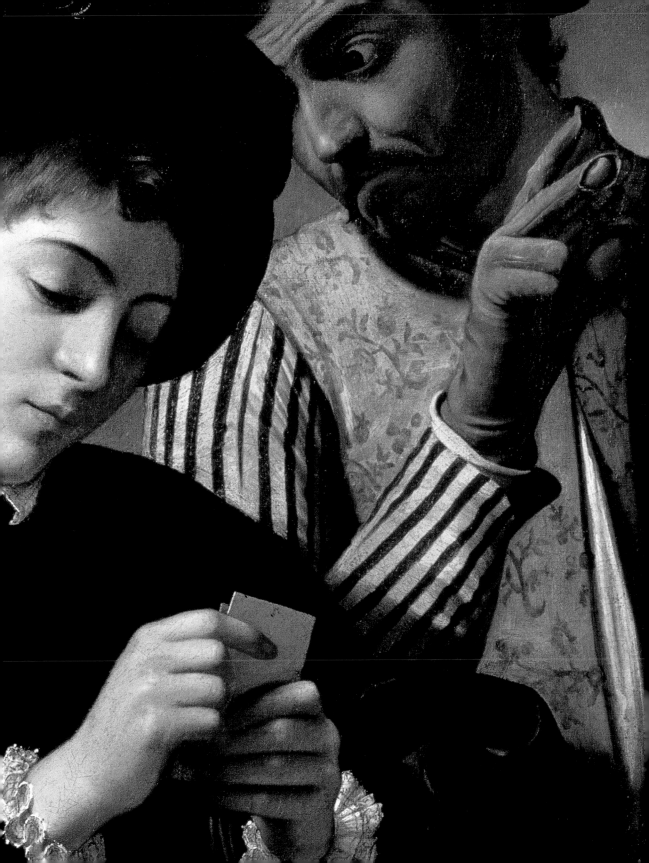

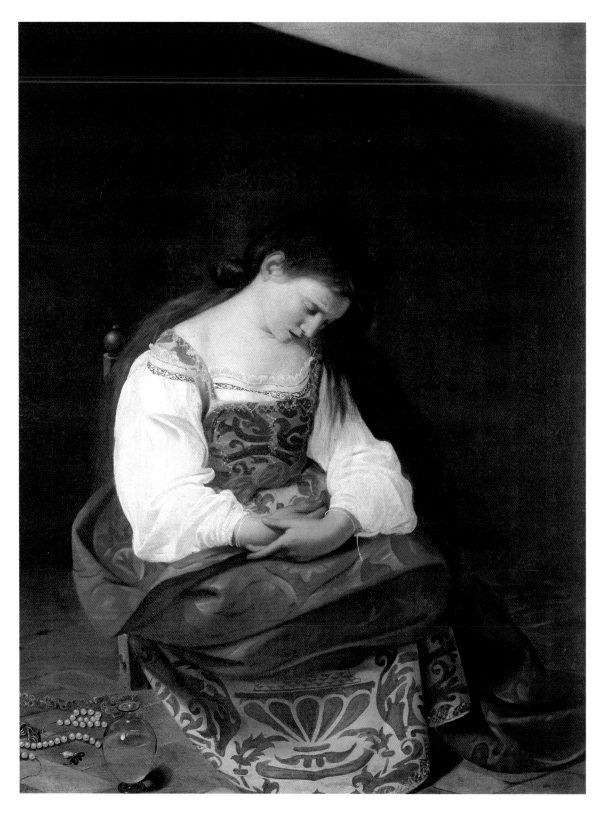

danger not only of being bound to servile imitation of the Old Masters, but of throwing off their idealism and technical expertise in favour of a hollow, superficial manner: paintings were made rather to be glanced at than studied". Caravaggio had little choice but to comply. He spent a period in the lower depths of Roman society among his fellow-exiles from Lombardy: unemployed stone-carvers, painters and sculptors awaiting commissions, and adventurers seeking easy pickings. He eventually found work with a Sicilian painter whose Roman career was well-established: Lorenzi. In Lorenzi's studio, he found other apprentices from Bergamo, the Longo brothers. By coincidence, the house of their father Marino the elder, a well-known architect, had been decorated by a painter thirty years older than Caravaggio, Polidoro Caldara (Polidoro da Caravaggio), who left a substantial corpus.

The life of Caravaggio and his friends, such as the Sienese painter Antiveduto Gramatica, spent in work, drinking, escapades in the brothels, and drunken expeditions into the vineyards of the *campagna* to visit the property of rich art-lovers, many of them known to him through the good offices of another impoverished young painter, Lionello Spada, who was to remain a loyal friend to Caravaggio. Scholars have sought in vain to identify the brushwork of the young Caravaggio in paintings of this period. It seems likely that he also painted some works purely for his own pleasure in this period; if so, they almost certainly ran counter to the prevailing fashion, and could not be sold.

PAGE 28:
Repentant Magdalene, 1596–1597
Oil on canvas, 122.5 x 98.5 cm
Rome, Galleria Doria Pamphilj

This is Caravaggio's first painting of a woman.

PAGES 30–31:
The Conversion of the Madgalene or *Saints Martha and Mary Magdalene,* c. 1598
Oil on canvas, 100 x 134.5 cm
Detroit (MI), The Detroit Institute of Arts

Detail of the jewellery of the *Repentant Magdalene*

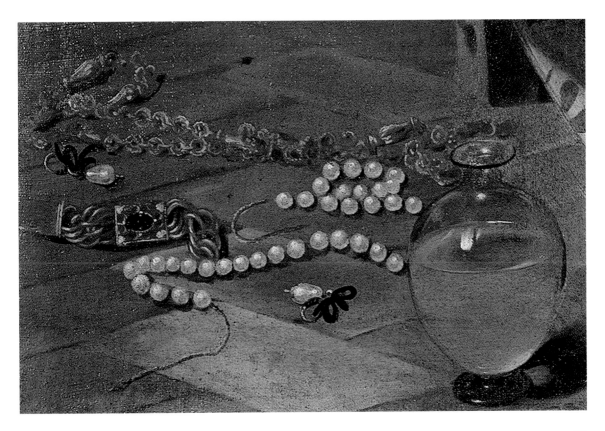

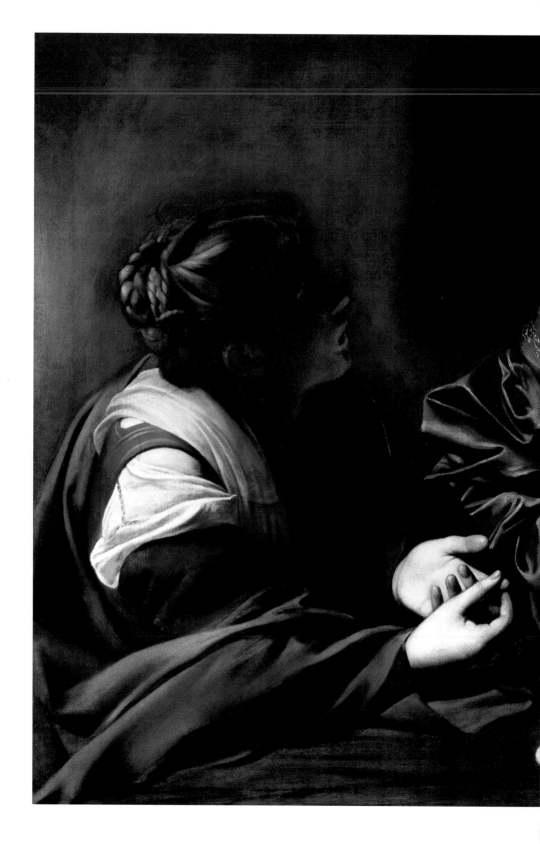

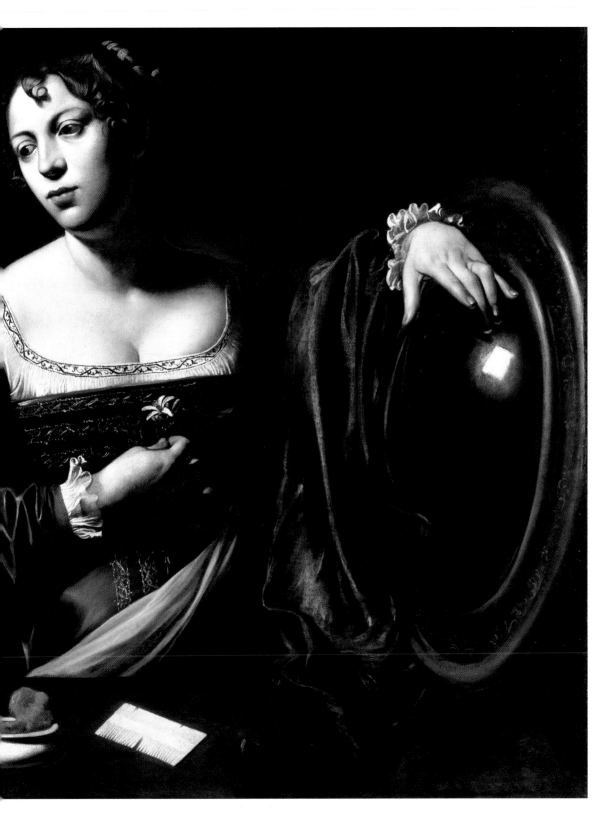

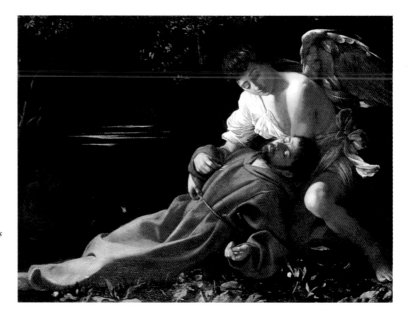

The Ecstasy of Saint Francis or *Saint Francis Receiving the Stigmata,* c. 1595
Oil on canvas, 92.5 x 127.8 cm
Hartford (CT), Wadsworth Atheneum

In the eyes of many critics, this work marks the birth of Baroque painting.

Tommaso Barlacchi
Narcissus, c. 1540–1550
Engraving

PAGE 33:
Narcissus, c. 1598–1599
Oil on canvas, 122 x 92 cm
Rome, Galleria Nazionale d'Arte Antica,
Palazzo Corsini

Then, suddenly, his fortunes changed. The instrument of this metamorphosis was a rich prelate, a "beneficiary of Saint Peter" who enjoyed a Vatican "pension". His name was Pandulfo Pucci, and, as the younger brother of the Cardinal Pucci who had, in his time, protected the redoubtable Benvenuto Cellini, he was abreast of the new artistic tendencies of the time. He also had a taste for young boys. Fascinated by Caravaggio's talent and facility, and attracted by his intransigence of character, he offered him board and lodging in return for copying religious paintings; Pucci sent them to the Capuchin convent in Recanati, his native village. None has been found.

Caravaggio had time to spare. He painted whatever he wished, whatever he imagined. Today, it is widely acknowledged that his *Boy Bitten by a Lizard* (ill. p. 18) – with its reminiscence of Sofonisba Anguisciola's drawing (ill. p. 19) – dates from the beginning of his stay with Cardinal Pucci. The young model is shown at precisely the moment when he reacts to the pain and jerks his hand away. The work is a revolution in itself, marking the advent of the instantaneous in painting. Berenson notes that this break with the conventional must have been perceived as astonishingly innovative. The painting is perhaps allegorical in intention, reflecting the pain inherent in love; the boy's bare shoulder and the flower behind his ear identify him as a prostitute. The painting is now in the Fondazione Longhi at Florence. A slightly different version, whose authorship is uncertain, is in the National Gallery in London.

Shortly afterwards, between two copies of the Madonna that have not survived, Caravaggio executed a *Boy Peeling Fruit* (ill. p. 8), which was long attributed to Murillo, and later to Le Nain. The *Boy with Vase of Roses* (ill. p. 8) belongs to the same period, as does the very beautiful *Concert of Young People,* sometimes called the *Musicians* (ill. p. 23). The last-named contains the painter's first surviving self-portrait, in the form of the singer at back right. The presence of a winged Cupid emphasises the homosexual character of the painting, which entered the collection of the Cardinal del

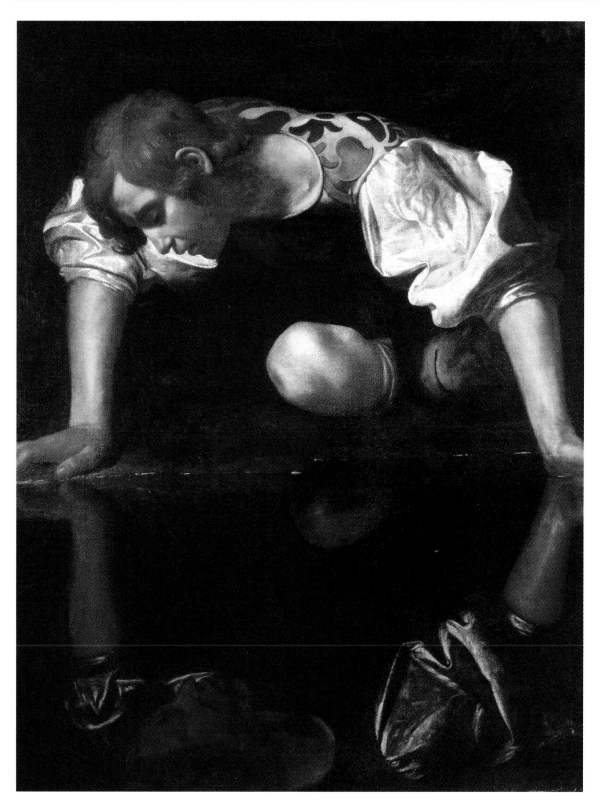

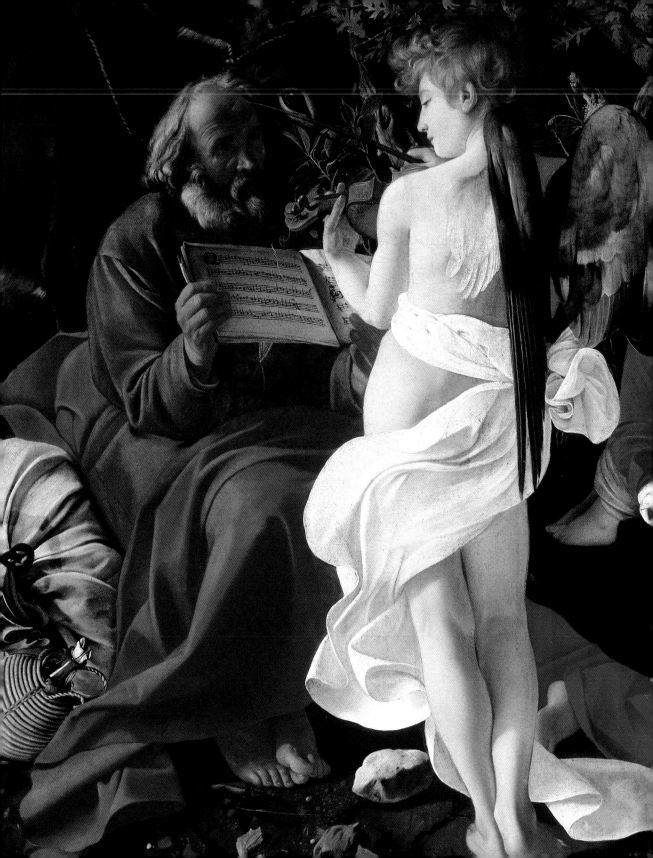

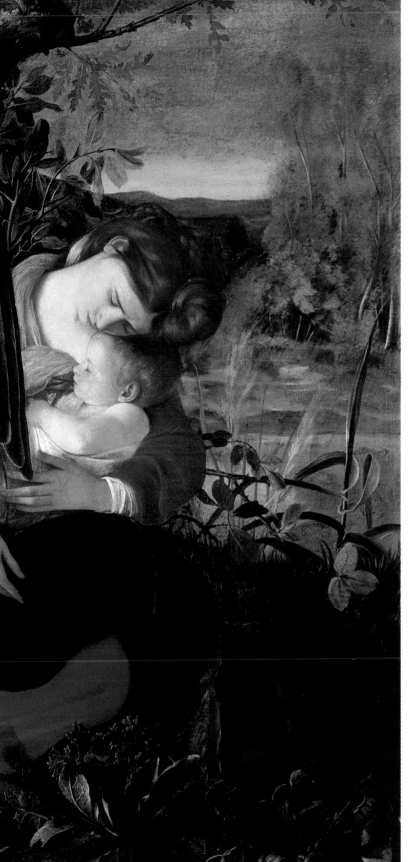

The Rest on the Flight into Egypt,
c. 1596–1597
Oil on canvas, 135.5 x 136.5 cm
Rome, Galleria Doria Pamphilj

Leonardo da Vinci
The Virgin of the Rocks, 1483–1485
Oil on panel, 199 x 122 cm
Paris, Musée du Louvre

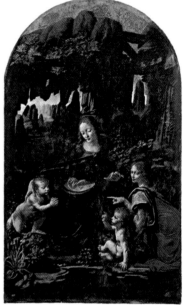

Titian
The Angel Gabriel, c. 1522
Detail of the Averoldi Polyptych, Brescia,
Santi Nazaro e Celso

35

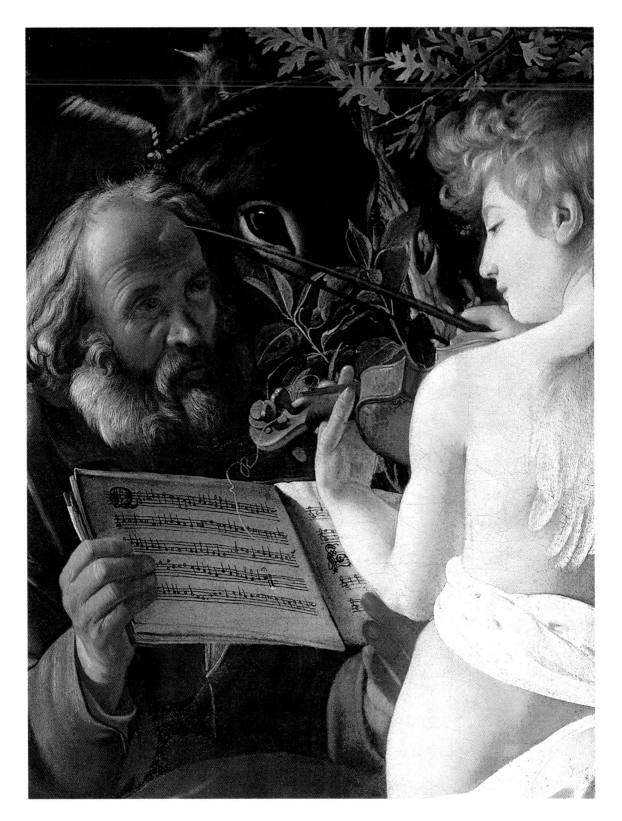

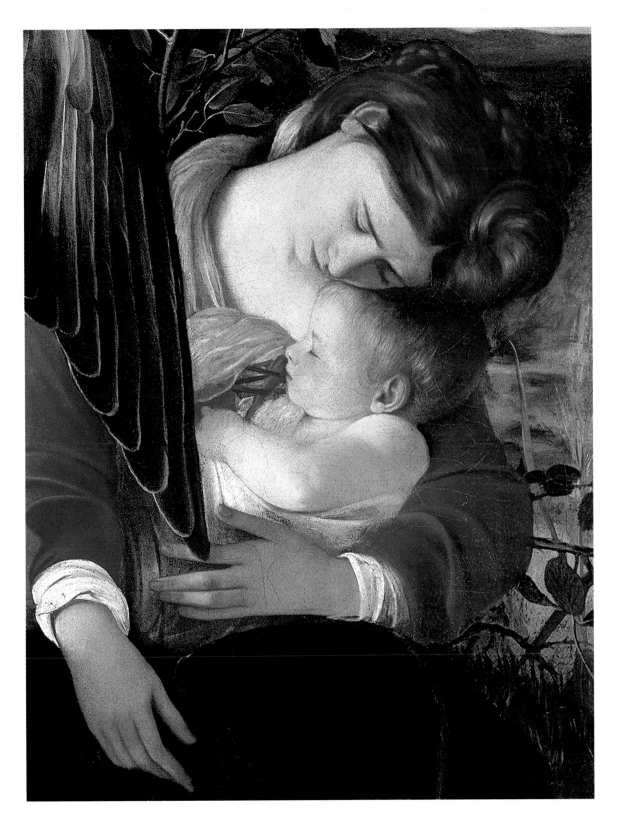

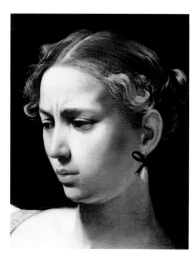

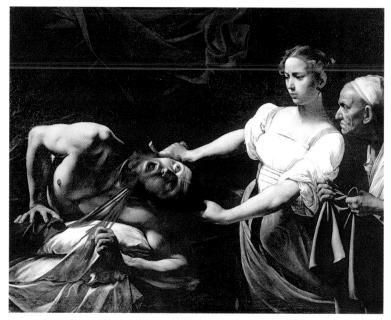

Judith and Holophernes, 1599
Oil on canvas, 145 x 195 cm
Rome, Galleria Nazionale d'Arte Antica,
Palazzo Barberini

The face of Judith is that of Caravaggio's
favourite model, Filli di Melandroni, who also
posed for the *Saint Catherine of Alexandria*
(ill. p. 12 and detail below) and for Martha
in the *Conversion of the Magdalene*
(ill. pp. 30–31).

Monte, another of Caravaggio's patrons. It was sold by his heirs, and reappeared only in 1894 in London, at a Christie's sale.

While staying with Pucci, Caravaggio also painted some still lifes. Three of these have been identified. They are now at the Galleria Borghese, Rome (one with flower and fruit, one with birds) and the Wadsworth Atheneum in Hartford, Connecticut. They were long considered to be the work of Flemish painters.

This was the period when Caravaggio painted the magnificent *Lute Player* (Hermitage, St Petersburg). The instrumentalist was one of his favoured models; there is a second version of the painting in the Metropolitan Museum, New York, in which the flowers and fruits have disappeared (ill. p. 14). The instruments are painted with minute attention to detail. The lute-player, with his salacious glance and ambiguous charm, seems to have escaped from the *Concert* to live his own life. In the Hermitage version, the score bears the mysterious phrase "Voi sapete chio v'amo" ("You know that I love you"): to whom is this declaration made? In the Metropolitan Museum picture, the score held by the half-naked singer in the foreground also contains a hand-written line, but it cannot, alas, be deciphered.

At this stage of his career, Caravaggio had yet to paint a woman. Only young boys inspired him. But a year later, he turned his hand to a very moving *Repentant Magdalene* (ill. p. 28).

Why did Caravaggio leave the residence of Cardinal Pucci, and perhaps, indeed, Pucci himself? We do not know. Pucci was a difficult character known for his avarice. His protégés were awarded a pittance so meagre that they dubbed him "Cardinal Salad". Caravaggio now found himself penniless and on the street, as he had been when he first arrived in Rome, three years before. He was taken in by Antiveduto Gramatica, his old friend from Lorenzi's studio. Gramatica had "made it"; he was obtaining commis-

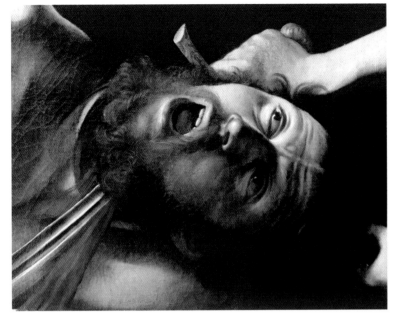

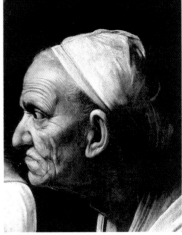

Details of *Judith and Holophernes:* the detached head, and the face of the old servant-woman who is about to take it.

sions, and was soon to be received as a member of the Accademia di San Luca.

Shortly afterwards, Caravaggio was struck down by an illness – Roman fever or the plague – that was raging throughout the peninsula. His friend Longo dragged him to the hospital for the poor, Santa Maria della Consolazione, where he left him, not, perhaps, expecting to see him again. Caravaggio lay among the dying in a dark underground chamber linking the hospital to the neighbouring Palazzo Colonna. Death seemed certain. He owed his life to the Prior of the hospital, a Spaniard named Contreras familiar with the Pucci household, who recognised him, had him transported to a more salubrious room, and commended him to the nuns' care. He survived, but the experience marked him forever, and there is a distant echo of it in several paintings, notably *The Death of the Virgin* (ill. p. 73).

While convalescing at the hospital, Caravaggio is said to have painted several canvases in gratitude for the intervention of the Prior. They were sent to Spain, where, according to Roberto Longhi, they made a deep impression on Velázquez and Zurburán. There is no trace of them today.

Caravaggio stayed almost six months in the hospital, and his stay inspired one of his best known works, the little *Ill Bacchus* of the Galleria Borghese (ill. p. 17). It is almost certainly a self-portrait; the figure is clearly that of the singer in the group of *The Concert*. The painting was made using a mirror, and the puffy flesh, livid complexion, and the rings around the eyes all suggest that he had not fully recovered. Indeed, he never did; all his life, he complained of head and stomach aches. The *Ill Bacchus* is a penurious god, whose stocks are limited to two apricots and two bunches of grapes. It was painted in the studio of the Cavaliere d'Arpino, then a highly fashionable painter, where the convalescent Caravaggio had been placed either by the Prior or by Cardinal Pucci – not it seems, a man to bear a grudge. The Cavaliere d'Arpino, a former boy-prodigy, was only a little

The "cabbage-leaf" ears, grimace and toothless mouth of the old servant-woman are inspired by heads drawn by da Vinci, such as this *Study for a Caricature*, Pinacoteca Ambrosiana

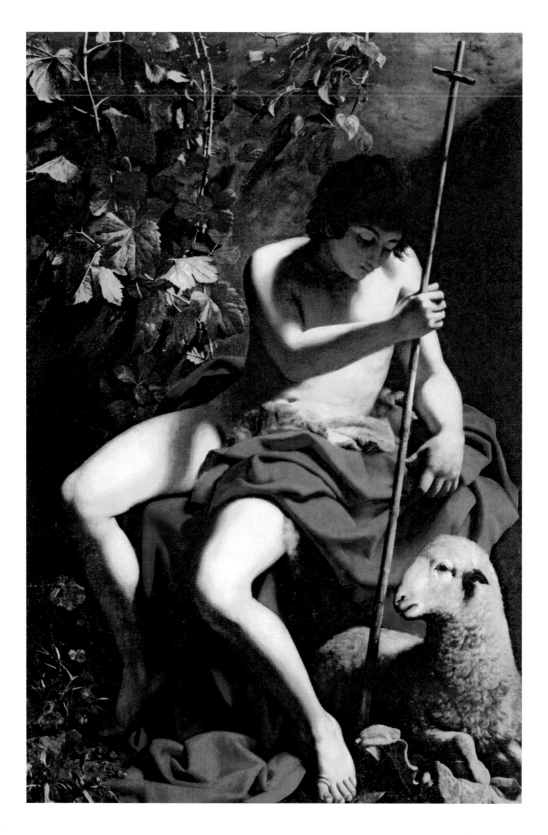

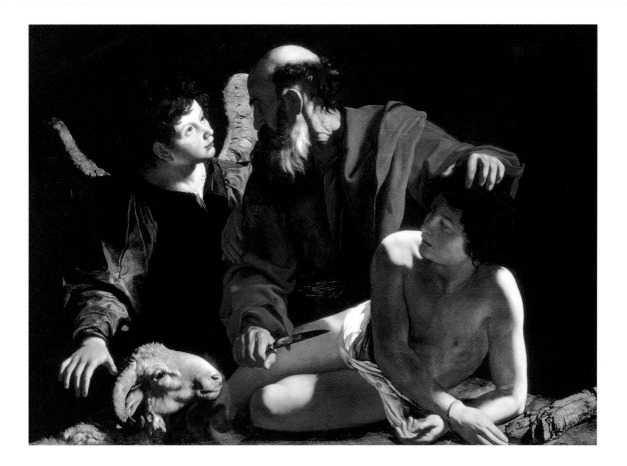

older than Caravaggio, but was an established society painter who moved in the circles of the papal court. Longhi describes him as an "arriviste". He belonged to one of the most active artistic fraternities of Rome, the Accademia degl'Insensati, so named because they promoted the divine over the evidence of their senses. Torquato Tasso, the poet Battesta Lauri and even the future Pope Urban VIII attended the Accademia. In the studio, Caravaggio took responsibility for the flower-and-foliage bordering the frescoes commissioned from the Cavaliere. The frescoes of San Atanasio dei Greci (the *Assumption* and *Coronation of the Virgin)* and Santa Prassede have been carefully studied for indications of Caravaggio's authorship. Jullian believes that the flowers in San Atanasio bear the stamp of Caravaggio.

The studio was an excellent place to meet the richest Roman artlovers: cardinals, ambassadors, and artists of high repute such as Van Dyke, Jan Breughel and perhaps Rubens, along with all the dealers of Rome. One of these, Valentin, who had recently arrived from France, took an interest in Caravaggio. In addition to the *Ill Bacchus* of the Borghese Caravaggio painted a *Boy with Basket of Fruit* (ill. p. 8) in the Cavaliere's studio; the painting was later given by Pope Paul V to his nephew Scipione Borghese. The two paintings remained in the studio; in 1607, they were seized in lieu of tax, along with a still life of a basket of fruit, by the agents of Paul V,

The Sacrifice of Isaac, 1596
Oil on canvas, 116 x 173 cm
Princeton (NJ), Collection Barbara Piasecka Johnson

PAGE 40:
Saint John the Baptist, c. 1597–1598
Oil on canvas, 169 x 112 cm
Toledo, Museo-Tesoro Catedralico

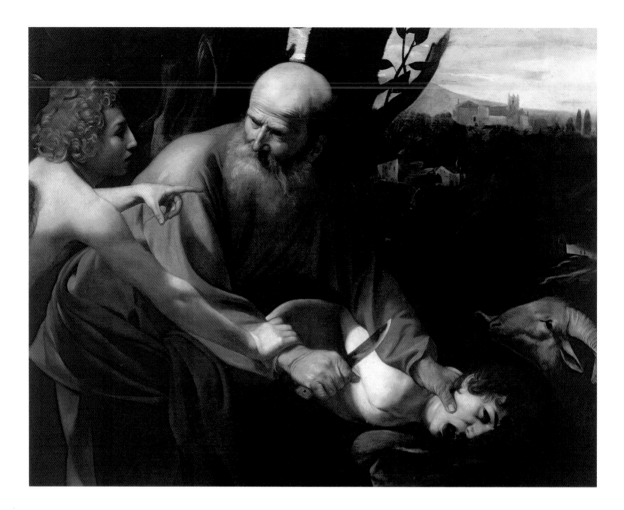

The Sacrifice of Isaac, 1603
Oil on canvas, 104 x 135 cm
Florence, Galleria degli Uffizi

PAGE 43:
Landscape detail from *The Sacrifice of Isaac*

who had succeeded Clement VIII. At that time, the Cavaliere d'Arpino was
out of favour and was imprisoned for illegal possession of an arquebus. It
is possible that Valentin at this period contrived to sell other works painted
by Caravaggio painted in almost clandestine fashion in the Cavaliere's
studio.

And then he was again out on the street. Though he knew the elite of
the art world, it was to the vagabond population of Rome that he returned.
Deaf to the advice of Valentin, sure of his own genius, intoxicated with his
new freedom, he spent his time in and around the Piazza Navona, mostly in
the company of penniless painters like himself. Longo had settled down,
but Lionello Spado took his place, along with Antonio Tempesta, another
fugitive from the Cavaliere's studio, and both were ready for any escapade
that offered. They provoked the Corte (the Vatican police), hung around
with the many Roman women of easy virtue, drank excessively and fright-
ened the bourgeoisie. Caravaggio was twenty years old and wanted to for-
get his copies of the Madonna, his frescoed floral border: to live and paint
as he chose. But he needed money. He turned to Valentin, who advised him
to paint religious scenes, for which demand was great. Caravaggio ac-
cepted, asked for paint and brushes, and returned to the dealer's house with

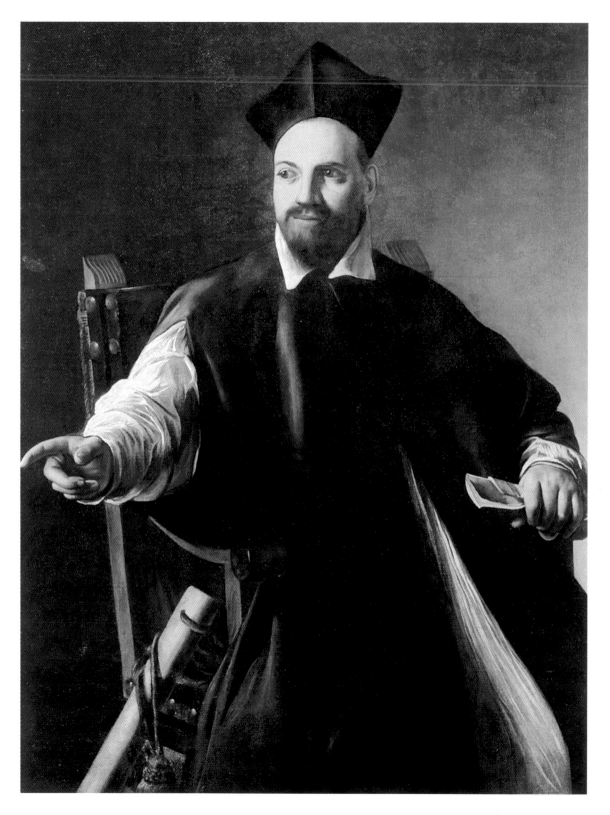

a second *Bacchus* (ill. p. 10) instead. This time the god wore the chubby features of a healthy boy with a drowsy stare; crowned with the traditional vine-wreath, he carries a glass goblet in his hand, which seems to have been served from the half-full carafe on the table. The painting in now in the Uffizi, in Florence. Certain details, such as the withered leaves of the wreath and the rotting fruits on the table, are deliberately provocative. This is the first picture cited by his implacable biographer, Baglione: "A *Bacchus* with several clusters of grapes, executed with great diligence, but rather coldly, at the time when Caravaggio was trying to work independently". The painting disappeared. It was miraculously rediscovered in 1916 by Roberto Longhi, who recognised it, despite its condition, in one of the storerooms of the Uffizi. When it was restored, a tiny reflection showing the head of a man wearing a white collar was revealed on the side of the carafe. Three hundred years late, the genius of the painter suddenly became evident.

The *Bacchus* was either refused or sold off for very little, and did nothing to solve Caravaggio's problems; he was still penniless. Convinced of his genius, Valentin begged him in vain to accept a "real" commission, for example, a Crucifixion. Instead, Caravaggio brought him a scene from the streets or the popular theatre, a *Fortune Teller* (ill. pp. 24–25), for which Valentin gave only thirty *écus*. The same painting was later bestowed by Louis XIV on Prince Doria Pamphilj, and is now in the Louvre.

Radiography has shown that the scene was painted over a Virgin in the style of the Cavaliere d'Arpino, to save money. This was the first painting of such a scene, and its vulgarity was deemed shocking – though it inspired the *Fortune Teller* by Georges de La Tour (ill. p. 94). Delighted to have served "Monsu" Valentin so ill, Caravaggio went out on a spree, which again ended in a confrontation with the Vatican police.

What happened thereafter? What arguments did Valentin use to convince the young painter? No doubt he held out the prospect of patronage from one of the richest art-lovers in Rome, his best client, Cardinal Francesco Maria del Monte. And Caravaggio: was he tired of life on the street? Did he experience some kind of mystical crisis? At all events, he accepted Valentin's offer and promised to paint a religious subject, the first of his career. But it was not a Crucifixion, a Deposition, or an Annunciation, nor even a Martyrdom. He chose to subject infrequently painted, *The Ecstasy of Saint Francis* or *Saint Francis Receiving the Stigmata* (ill. p. 32). He set to work in Valentin's cellar, determined to acquit himself of this chore as quickly as possible.

And, of course, he painted a masterpiece, which opened to him the doors of the great Roman collectors. It brought him both reputation and the esteem of powerful patrons, and may be considered his first mature work.

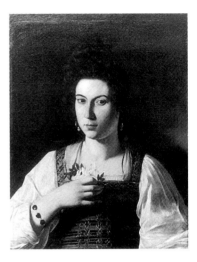

Phyllis, c. 1596–1597
Oil on canvas, 66 x 53 cm

This work was destroyed during the Second World War. It belonged to the Kaiser-Friedrich-Museum, Berlin.

PAGE 44:
Portrait of Maffeo Barberini (later Pope Urban VIII), c. 1598–1599
Oil on canvas, 124 x 90 cm
Florence, private collection

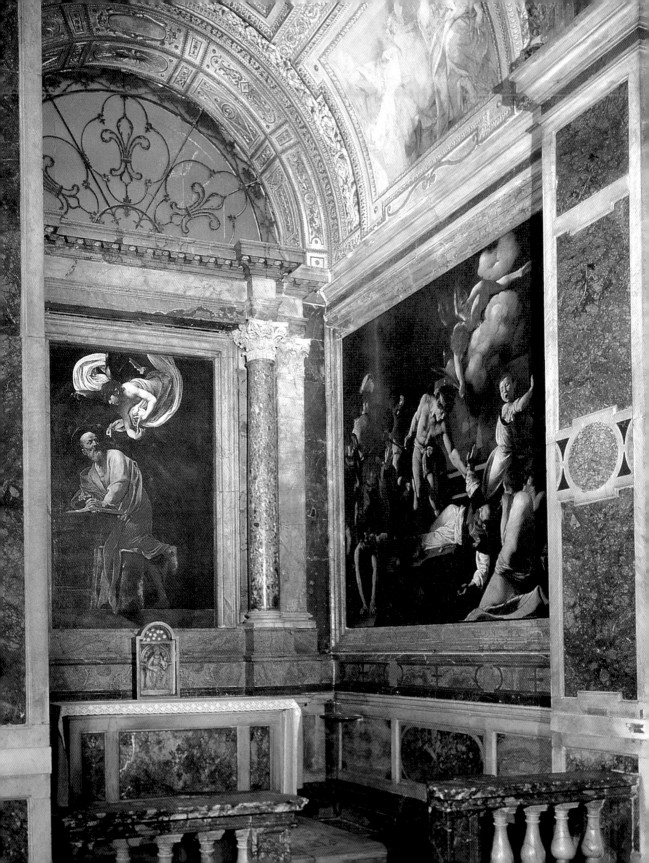

The Master of Darkness 1592–1606

The Ecstasy of Saint Francis (ill. p. 32) has elicited a variety of critical re-actions. For Dominique Fernandez, it marks the advent of the Baroque. The painting had received little serious analysis till the work of Pamela Askew, who drew on the writings of Saint Bonaventura. The scene takes place at night. In the background, the shepherds have lit a fire, which casts its light onto the sky; by its glow, we can make out the Saint's companion, Brother Leone. Saint Francis is receiving the stigmata in a state of mystical ecstasy, which had never before been depicted in this manner: he leans back into the arms of a sensual adolescent, one of the painter's favourite models, whom it is not easy, despite his wings, to take for an angel. Nevertheless, the scene is imbued with a powerful mystic emotion. Two years before the invention of opera in Monteverdi's *Orfeo* and well before Bernini's fa-mous *Ecstasy of Santa Teresa*, this is the first artistic representation of the "swoon". With its play of light and theatrical composition, it is also an as-tonishing display of theatrical effect.

The *Saint Francis* prefigures Caravaggio's great religious composi-tions, in particular the *Conversion of Saint Paul* in Santa Maria del Popolo (ill. p. 67). Cardinal del Monte immediately perceived it for what it was: a new way of painting. Its author was summoned to the Palazzo Madama, not far from the Piazza Navona.

Francesco Maria del Monte was a most unusual cardinal. He was the Duke of Toscany's ambassador to the Pope, and in this capacity, inhabited the Villa Medici, which was later symbolically leased to the King of France. He read Ancient Greek, Hebrew and other Oriental languages. He was ru-moured to practise alchemy. He was open to new ideas, and a great music lover, who gave audiences surrounded by his court like a king. Caravaggio, who was hard to impress, nevertheless impressed the Cardinal, who offered him bed, board and liberty. At Valentin's prompting, the young man ac-cepted. As a lodger at the Palazzo Madama, he became a prominent artist: controversial, admired and hated in equal measure, but above all, famous.

It seemed for a while as if he had learnt his lessons. His needs were met, he was well looked after, and his genius flowered. The directness of his language combined with his quest for dramatic effect, giving his paint-ings a sense of the instantaneous – today we would speak of "suspense" – in a chiaroscuro that was growing ever more intense in its contrasts. With-out curbing his need to provoke and surprise, his dissident attitudes, or his hostility to convention, subordination and mendacity, he produced master-pieces that astonished, alarmed and thrilled his patrons. The austerity of the

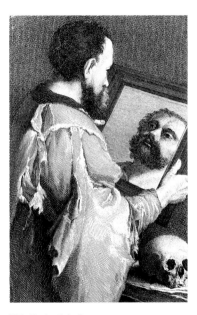

This *Vanitas* is in fact a contemporary engraving of a lost work by Caravaggio: *Self-Portrait in a Mirror*

PAGE 46:
View of the Contarelli Chapel in San Luigi dei Francesi, Rome, showing the right-hand wall; to the left, *Saint Matthew and the Angel,* and to the right, *The Martyrdom of Saint Matthew*

The Martyrdom of Saint Matthew, 1599–1600
Oil on canvas, 323 x 343 cm
Rome, right-hand wall of the Contarelli
Chapel in San Luigi dei Francesi (ill. p. 46)

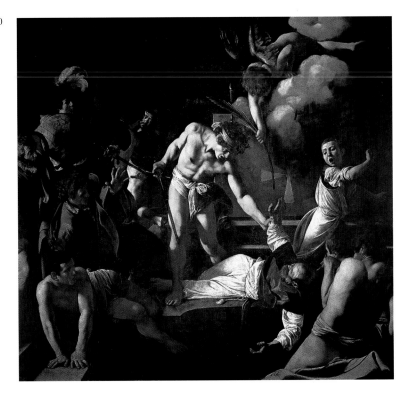

PAGE 49:
Detail of the self-portrait from the
The Martyrdom of Saint Matthew

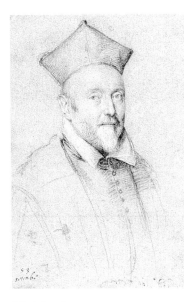

Ottavio Leoni
***Portrait of Cardinal Francesco Maria del
Monte,*** 1616
Sarasota (FL), John and Mable Ringling
Museum of Art

Counter-Reformation was abating. The turn of the century was at hand, and Mannerism was already a thing of the past. The Renaissance was distant history. This was the time of the Edict of Nantes. Italy and France were allies: Henri IV was to marry Maria de' Medici. Michelangelo Merisi now called himself "Caravaggio"; he was twenty-five. As the Cardinal's lodger, he could allow free rein to his "thirst for painting", and alternate religious and profane subjects. He painted a moving *Repentant Magdalene* (ill. p. 28) whose model was a woman from the streets, Giulia, perhaps his mistress. Berenson notes that the green cloth of her dress reappeared in a number of later works. He later painted a more elaborate *Conversion of the Magdalene* or *Saints Martha and Mary Magdalene* (ill. p. 30–31).

The often-reproduced *Basket of Fruit* (ill. p. 20) was probably painted early in his stay with del Monte. This was the first still life to be painted from this angle, in *trompe-l'oeil* fashion. The edge of the basket hangs precariously over the edge of the table on which it sits. In the basket, rotten fruit and withered leaves are juxtaposed with fresh. Should we see in it a reference to certain religious customs that disgusted Caravaggio? It is said that Cardinal del Monte turned away from the painting with tears in his eyes. He did not, at all events, keep it, since it reappears in the studio of the Cavaliere d'Arpino, where it was seized in lieu of tax. Thereafter, the work was forgotten. It was generally assumed to be a Flemish import. The Milan *Basket of Fruit* was attributed to Caravaggio by Longhi in 1991, and today no one would dream of ascribing it to any other artist.

It is possible that Caravaggio briefly exchanged the Palazzo Madama for that of the Cardinal Maffei, another of Valentin's clients. But it was del

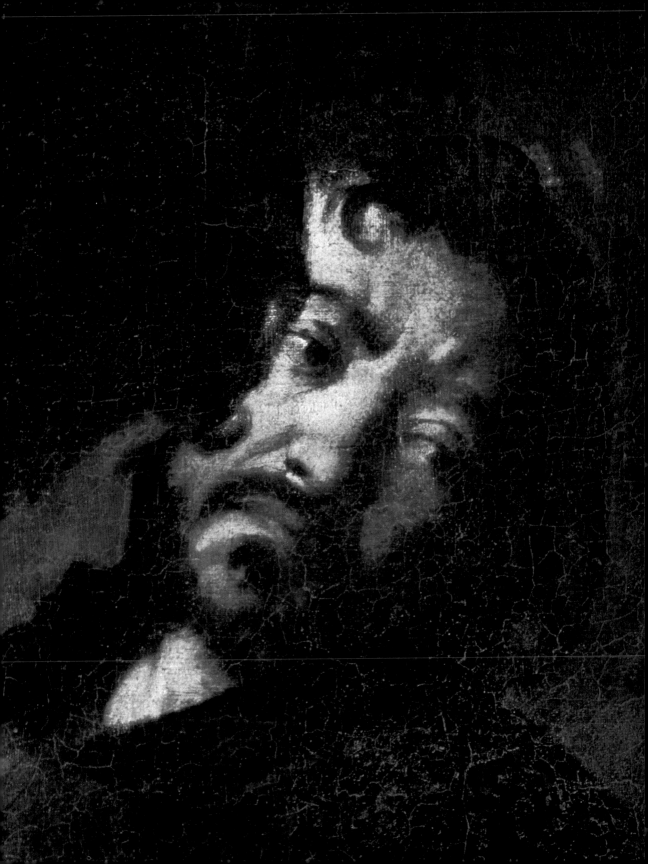

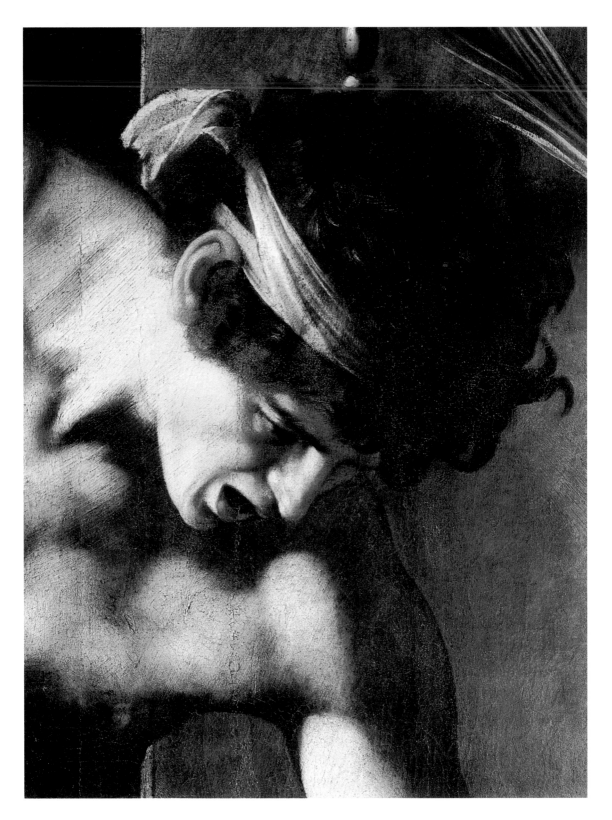

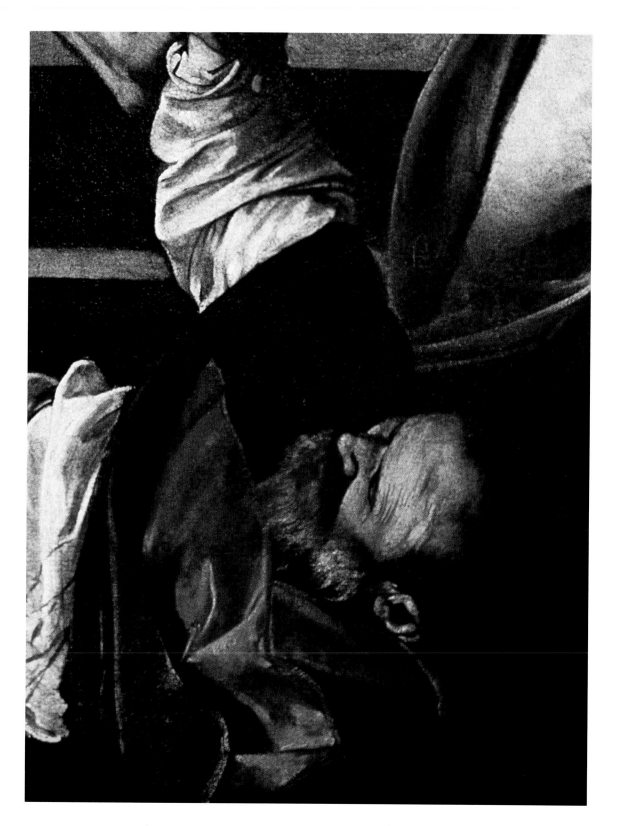

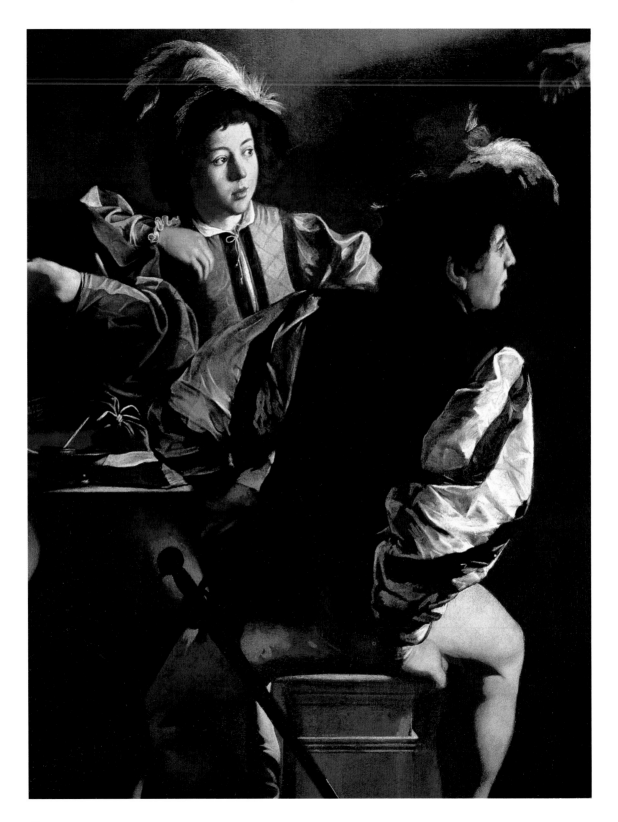

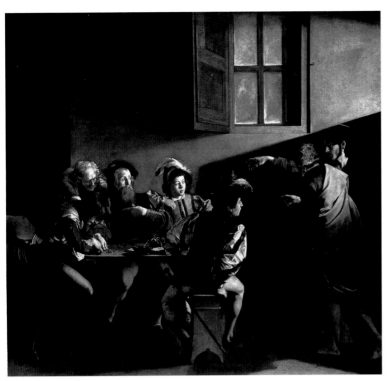

PAGES 50-51:
Details of *The Martyrdom of Saint Matthew*

PAGE 52:
Detail of *The Vocation of Saint Matthew*

In *Les Voix du Silence* (1952), André Malraux wrote that Caravaggio had died too young "to attain to unity… it was Rembrandt who discovered what Caravaggio despairingly sought: the form of light that draws humble figures out of the darkness and bestows eternity upon them".

LEFT:
The Vocation of Saint Matthew, 1599–1600
Oil on canvas, 322 x 340 cm
Rome, right-hand wall of the Contarelli
Chapel of San Luigi dei Francesi

Monte's collection that received two canvases from this period, the *Fortune Teller* (ill. pp. 24–25) and the *Cardsharps*, also called *Card Players* (ill. p. 26). These are the first paintings with three protagonists, in the Venetian format, with three-quarter profiles, and Caravaggio often returned to it. There was a further novelty here: humour. Not only was *la maniera* ousted, but here were street or theatre scenes, and in them, characters wearing malicious or perverse expressions. The Cardinal could not believe his eyes. Radiography has shown that the *Fortune Teller* was painted on a used canvas; the many *pentimenti* testify to the fact that there was no preliminary drawing. There are two copies of this painting, both apparently authentic (the other is in the Pinacoteca Capitolina, Rome). As to the subject of the *Cardsharps*, Giovanni Pietro Bellori writes that the anecdote – the sign made by one of the characters to his accomplice – was considered by some a vulgarization of art. When del Monte died, the *Cardsharps* passed to the Colonna family, who sold the painting to a Rothschild in 1899.

The strange *Head of the Medusa* (ill. p. 4) also dates from this period; the canvas is mounted on a tourney shield. Why did Caravaggio choose this extraordinary theme? Leonardo was reputed to have painted a Medusa's head, which has since disappeared: did Caravaggio intend a parody? The expression of the face is terrifying. Berenson, who had witnessed a decapitation, felt a similar horror before this work. It was sent by del Monte to the Duke of Tuscany, and has never left Florence.

Caravaggio now returned to religious subjects, no doubt at Valentin's exhortation. Till now, the only such paintings we know had been the *Saint Francis* and the *Penitent Magdalene.* Faithful to his own notion of the

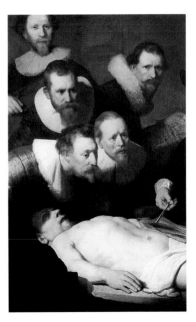

Rembrandt
The Anatomy Lesson of Doctor Tulp (detail), 1632
Oil on canvas, 169.5 x 216.5 cm
The Hague, Mauritshuis

53

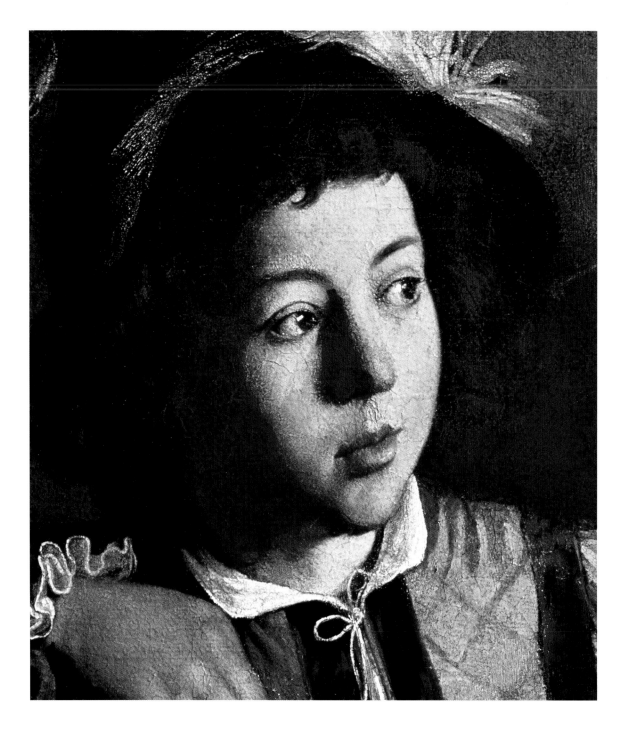

Details of *The Vocation of Saint Matthew*

painter's role, he sought dramatic subjects and situations, which had rarely been represented; in these, his theatrical compositions and intense chiaroscuro could combine to powerful effect.

 The Arrest of Christ (Dublin, National Gallery of Ireland), recently attributed to Caravaggio, and the *Sacrifice of Isaac* (ill. p. 42) are treated as

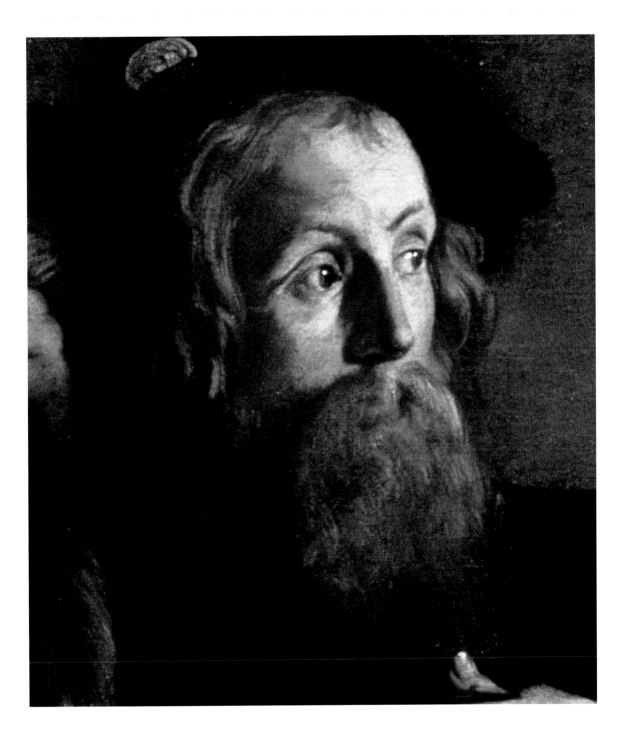

though they were everyday events. In the *Sacrifice of Isaac* (1595), we see a
very human angel, a *putto*, approach Abraham as he prepares to cut his
son's throat. The angel is stroking the ram that will replace the child. Some
have seen in this picture the influence of the Cardinal of Milan, Frederico
Borromeo, the former Chamberlain to Sixtus V, who, in passing through

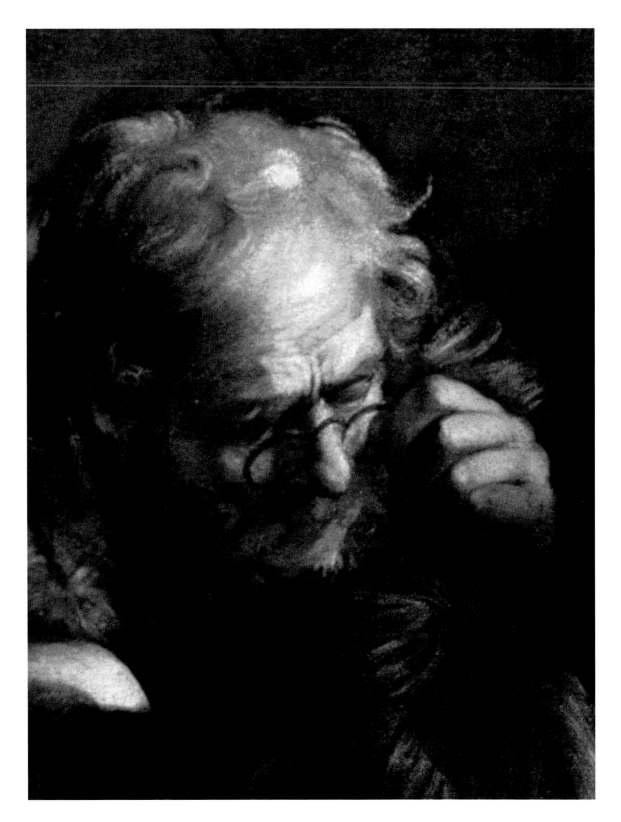

Rome, was profoundly impressed by Caravaggio's work. A *Saint Catherine of Alexandria* (ill. p. 12) displays, amid a masterly play of light and shade, the wheel studded with metal spikes used to torture the Saint. The painting was part of the del Monte heritage, and was sold to the Barberini family, in whose possession it remained until 1935, when it entered the Thyssen collection.

Another religious work of this period is a *Saint John the Baptist* (ill. p. 6), which is clearly inspired by Michelangelo's *Ignudi* in the Sistine Chapel (ill. p. 7). He also painted a second *Magdalene* (*The Conversion of the Madgalene,* ill. p. 30–31), who appears with the courtesan Martha and a mirror, in a style reminiscent of the Venetian masters. The model for Martha (and *Saint Catherine)* was Filide Melandroni. The painting was bought by the Gomez family and remained in Argentina until 1965.

The demand for religious subjects, combined, no doubt, with pressure from the cardinals, incited Caravaggio to paint other scriptural subjects, but these had little in common with the prevailing sweetness of tone. He chose a terrible scene from the Apocrypha, that of Judith cutting off the head of the Assyrian captain Holofernes (ill. p. 38). Again, his model was Filide Melandroni. Examination by X-ray has shown that she was originally barebreasted, and that a garment was subsequently painted in to hide this. An old servant-woman with a cruel expression is helping Judith and waiting to catch the head in a cloth. Here Caravaggio was inspired by Leonardo, whose drawing, done in his old age, is now in the Pinacoteca Ambrosiana in Milan (ill. p. 39). Caravaggio in his turn inspired Artemisia Gentileschi,

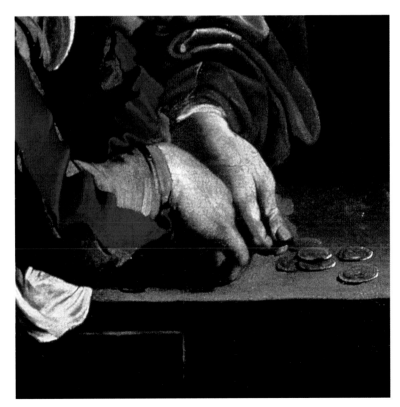

PAGE 56 AND LEFT:
Details of *The Vocation of Saint Matthew*

57

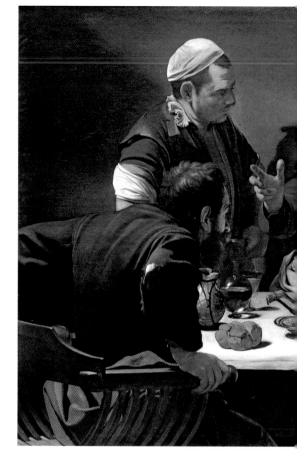

Leonardo da Vinci
The Last Supper, 1495–1498
Oil and tempera on plaster, 460 x 880 cm
Milan, refectory of the Convent of Santa
Maria delle Grazie

the daughter of his close friend, Orazio Gentileschi. Having been raped as a young girl by a friend of Caravaggio and her father, she painted several versions of Judith decapitating Holophernes in an attempt to exorcise her hatred of men.

The Rest on the Flight into Egypt (ill. pp. 34–35) similarly defies convention and tradition: the Virgin has russet hair, contrasting with the red-blonde curls of the Christ child on whom she leans her head. A angel, seen from the back, plays the violon, as he follows the score held out by Saint Joseph, a bare-foot peasant seated on a sack with his flask of wine at his feet. The pastoral background, the distant horizon and the decor of flowers are all reminiscent of Giorgione, though Caravaggio's power of description is still greater. *The Rest on the Flight into Egypt* received a rather lukewarm reception in Rome, but this limited success did not concern Caravaggio. His name was on everyone's lips. Cardinal del Monte commissioned him to paint the ceiling of his country house, today known as the Villa Boncompagni Ludovis. This is the only fresco ascribed to Caravaggio, and has only recently been identified. In a perspective worthy of Mantegna, we see *Jupiter, Neptune and Pluto*, and are able to measure the extraordinary technical virtuosity of the twenty-six year old artist.

The fresco was a success and confirmed Caravaggio's authority. But

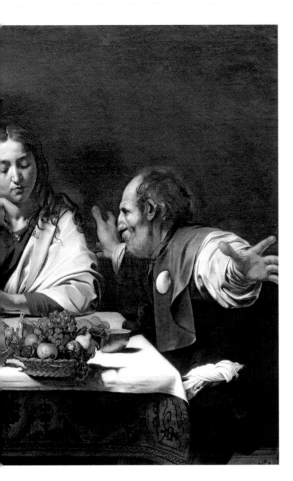

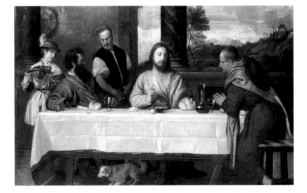

The Supper at Emmaus, 1601
Oil on canvas, 141 x 196.2 cm
London, National Gallery

Titian
The Supper at Emmaus, c. 1540
Paris, Musée du Louvre

Valentin had greater things in mind for him. Before the turn of the century, he had obtained for him a much more prestigious commission, for one of the most fashionable churches in Rome, San Luigi dei Francesi.

Four centuries have passed, and the two great paintings by Caravaggio are still to be found in San Luigi, exactly where they were hung in the presence of the painter, after considerable to-do; they are *The Martyrdom of Saint Matthew* (ill. p. 48) and *The Vocation of Saint Matthew* (ill. p. 52). They mark a new phase in the life and work of the painter. It was the greatest ensemble that he had yet attempted, and the impact was considerable. The revolutionary aspect of these works gave rise to a violent polemic. And the debate persisted; at the outset of the 17th century, religious frescoes and paintings were a common topic of conversation. People were anxious to see any new work, sometimes queuing for hours to enter the church where a work was displayed.

The story of the San Luigi dei Francesi commission is a complex one. Cardinal Contarelli, a native of Sarthe (he was born Mathieu Cointrel), had bought a chapel there, and wanted to see it sumptuously decorated and dedicated to his patron saint, Matthew. He died before work was completed, and his estate proved difficult to administer; a succession of trials resulted. Several artists worked on the Contarelli chapel, among them Girolamo?

Muziano and the Cavaliere d'Arpino. The latter painted on the vault another episode in the life of Saint Matthew, the *Resurrection of the Daughter of a King*. He had agreed to fresco the sides of the chapel, but for some reason withdrew, and the commission fell to Caravaggio: the contract, dated 25 June 1599, for the sum of four hundred *écus*, has survived. How did the commission come to Caravaggio, when many more illustrious Roman painters were actively seeking it? The answer must lie in the manoeuvres of his patrons, Cardinal del Monte and the banker Giustiniani, who had taken a keen interest in the young painter. Caravaggio was flattered and set to work. But a difficulty immediately arose; the Contarelli chapel remained a place of worship, and it seemed improper to fill it with scaffolding. Caravaggio proposed giant canvases: 3.40 x 3.22 metres. This was unheard of, but his suggestion was accepted nonetheless.

In *Le Dossier Caravage* (Editions de Minuit, 1958), Berne-Joffroy wrote: "Caravaggio must have felt intimidated and yet full of a burning desire to demonstrate his true powers. His state of mind is easy to imagine. He wanted to surpass himself. He remembered that his previous works had received many compliments but many brickbats. In particular, he remembered that he was accused of compositional ineptitude".

He delivered the *Martyrdom of Saint Matthew* a few months late, early in 1600. The X-rays made by Lionello Venturi have shown that Caravaggio changed his mind several times in the course of painting the *Martyrdom*. The scene is set in the court of Ethiopia, whose king has the Saint assassinated while he is conducting a service. Officiating in this way was a crime in

PAGE 61 AND BELOW:
Details of *The Supper at Emmaus*

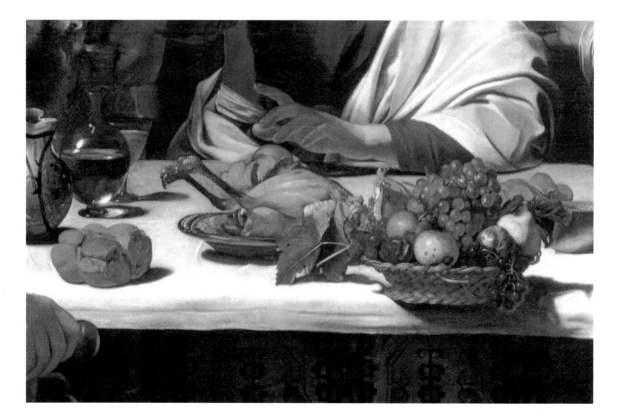

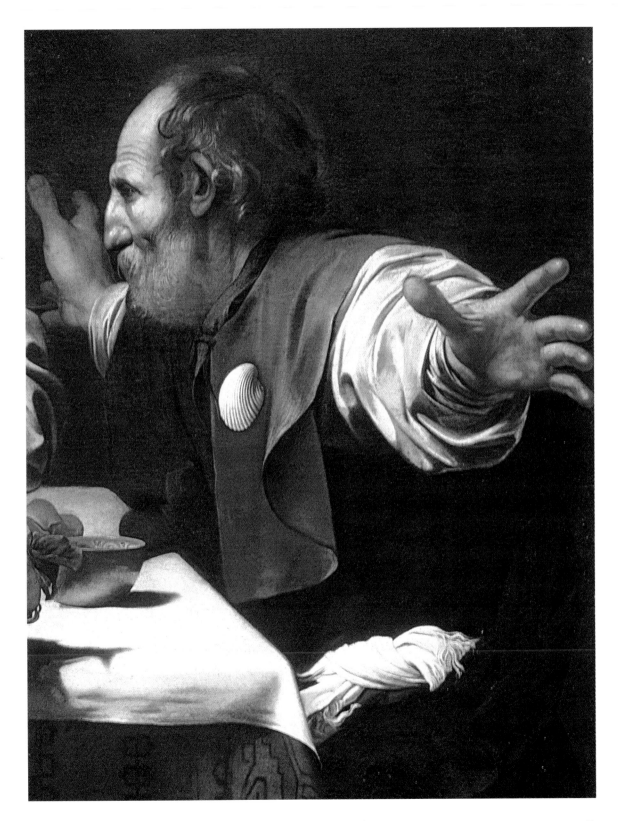

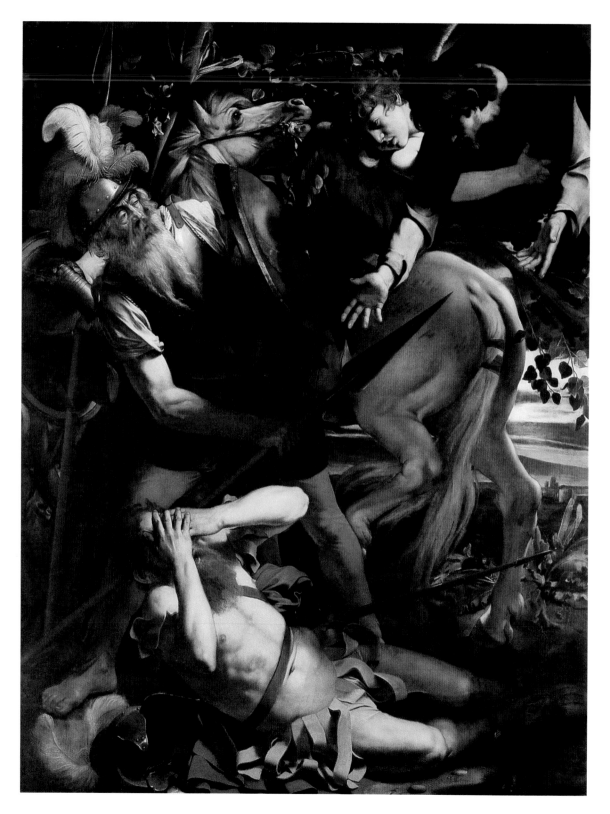

Ethiopia, and the executioner is wreaking vengeance in thus eliminating a rebel. The dying Matthew seems to reject the martyr's palm held out to him by a cloud-borne angel. The composition has given rise to many interpretations. A young man with a gentle expression shows terror at the unfolding spectacle. A child turns away with an expression of unspeakable horror. One of the witnesses, his expression tormented and his beard thin, is a self-portrait, the third after the *Ill Bacchus* and the singer in the *Musicians.*

The realism and emotional intensity of the *Martyrdom of Saint Matthew* were found overwhelming. "By applying his luministic invention to a complex ensemble of figures, Caravaggio necessarily abandoned the linear methods used by Taddeo Zuccari and Giuseppino to guide the spectator's eye," Herman Voss writes: "Having already acquired an extraordinary mastery of chiaroscuro, Caravaggio now possessed an instrument adequate to his task. He was thus able to obtain an emphasis on the essential such as the Mannerists could never achieve." His competitors were not impressed. Taddeo Zuccari declared: "What a storm in a teacup! I saw nothing in this work but a copy of Giorgione's style."

The Vocation of Saint Matthew, which stands next to the *Martyrdom*, was delivered a few months later, and did nothing to dispel the controversy. Caravaggio illustrated the mystery of the vocation with a scene from contemporary Roman life. His highly audacious setting was at first taken to be a tavern or a gambling den. In fact, it is a tax office, in which an excise official is working at his accounts. The light enters from the top right of the canvas. The only window is closed, and seems always to have been so. Into this unexpected décor bursts Christ, pointing to one of the men with an imperious gesture that evokes the *Creation of Adam* in the Sistine Chapel. "This revolutionary work marks the beginning of a new age in painting," wrote Valerio Mariani, in 1958.

Caravaggio's fame was now secure. He had proved that the divine miracle could be represented in a setting from daily life, that Christ could be painted in the office of an excise officer. He had also shown that a chapel could be decorated with scenes painted on canvas. There were objections; but the Contarelli's executors were satisfied, and Caravaggio was chosen for the altarpiece, which was to be a *Saint Matthew and the Angel* (ill. p. 70). Caravaggio met his deadline, but the work was refused because the Saint bore the features of a bald, bearded peasant with bare legs and dirty feet. Moreover, the posture of the angel guiding his hand was rather too languid. The Marchese Giustiniani bought the painting, which was sold by his descendants to the Kaiser-Friedrich-Museum in Berlin in 1815, and there destroyed during the Second World War.

Shortly afterwards, Caravaggio submitted another interpretation of the scene (ill. p. 71). There is no physical contact between the Evangelist and the Angel who inspires him. The altarpiece is still in San Luigi dei Francesi; the ensemble was lost in the shadows of the Contarelli chapel, and only came to light with the "rediscovery" of Caravaggio by Roberto Longhi and the 1922 exhibition in Florence. It was restored in 1939. Until some years ago, you had to place a coin in the slot to obtain a few minutes light in which to admire the ensemble.

The polemics set off by San Luigi dei Francesi brought Caravaggio another and equally prestigious commission for the Cerasi chapel in Santa Maria del Popolo, in one of the most beautiful squares in Rome. The Cerasi

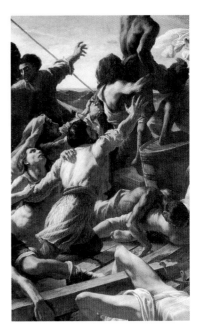

Théodore Géricault
The Raft of the Medusa (detail), 1818–1819
Oil on canvas, 187 x 491 cm
Paris, Musée du Louvre

PAGE 62:
The Conversion of Saint Paul, 1600–1601
(first version refused)
Oil on cypress panel, 237 x 198 cm
Rome, Prince Guido Odescalchi Collection

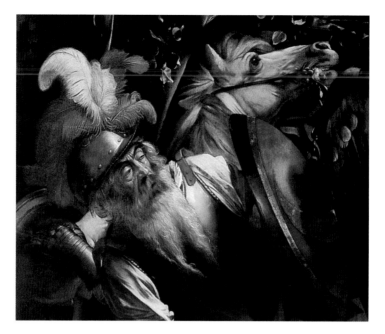

Detail of the ***Conversion of Saint Paul*** (first version)

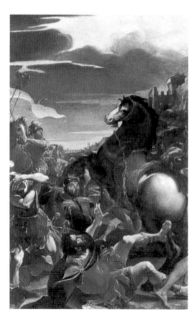

Ludovico Carracci
Conversion of Saint Paul, 1587–1589
Bologna, Pinacoteca Nazionale

family had bought the chapel to the left of the main altar as a family funerary chapel.

The date is 1601. During the winter, the Tiber overflowed its banks and Giovanni, an apprentice of Caravaggio's, was drowned in a cellar of the del Monte palace. While Valentin was negotiating a contract with the intransigent Cardinal Tiberio Cerasi, retired treasurer of Pope Clement VIII, Caravaggio painted *The Death of the Virgin* (ill. p. 73). Marchese Giustianini was manoeuvring to have it bought by the discalced Carmelites of Santa Maria della Scala, in the Trastevere. It is the largest altarpiece by Caravaggio, and it was, again, a source of considerable scandal.

The *Vocation of Saint Matthew* was depicted in a tax office; the decor of the *Death of the Virgin* is set in a rented room, divided by the great red curtain hanging from the wooden beams, and bare of any furniture other than a simple bed, a chair and a basin. "They are lamenting the death of a women of the people who is known throughout the quarter," writes Longhi. "It is a scene from a night shelter. But the anguish of those present seems to have an infinite and indelible character, imparted by the devastating brightness of the shaft of light that arrives from the left and, grappling with the shadows, dwells on bald heads, shaking necks and hands trailing in despair."

The Carmelites, needlessly to say, refused the picture. There was, after all, a rumour that Caravaggio's model had been a prostitute. The body suggested illness, and the basin of vinegar in the foreground, ready for the washing of the body, was considered blasphemous, as it called into question the Resurrection. The work was dangerous; the previous year, Giordano Bruno, whose writings contested the teachings of the Church, had been burnt alive in Rome when he refused to retract.

The *Death of the Virgin* found no taker. It was eventually bought for the collection of Vincente Gonzaga, Duke of Mantua, on the advice of

Detail of the **Conver-
sion of Saint Paul**
(second version)

Rubens, who had stayed in Venice on his way from Antwerp to Rome.
Rubens was fascinated by the power, audacity and chiaroscuro of Caravag-
gio, though he thought it a failing that Caravaggio did not make prepara-
tory drawings. In 1628, the painting was sold to Charles I of England, along
with majority of the Duke of Mantua's collection. At the death of the King,
it was briefly in the possession of the Parisian banker Jabach, before being
acquired by Louis XIV.

Caravaggio, meanwhile, did little or nothing in fulfilment of his Santa
Maria del Popolo contract. Valentin was alarmed to find that Caravaggio
had returned to his friends from the Roman underworld, was again quar-
relling and drinking, and occasionally disappeared without trace. He never-
theless agreed to paint a *Crown of Thorns* in portrait format for Marchese
Giustiniani, who was increasingly prosperous. The original, which was
mistaken for a contemporary copy, was identified in 1974; it is now in the
Cassa di Risparmio at Prato. The expression and pained gaze of Christ are
heart-rending. The executioner was drawn from a well-known model and
drinking-partner of Caravaggio's. He also painted, in a remarkably short
time, an *Entombment* (ill. p. 74), a superlative painting in which the treat-
ment of light is remarkable and the very bright colours continue to surprise.
This was the only religious work of Caravaggio to be immediately and
without reservation accepted by his patrons, the heirs of Cardinal Vitrici,
who commissioned it for the church of the "Chiesa Nova" of Santa Maria
in Vallicella. Rubens made a copy (ill. p. 75), though for some reason he left
out the figure of "Mary called Cleopas".

Valentin eventually finalized the contract for Santa Maria del Popolo;
it was rediscovered in 1920 by Denis Mahon and published in the *Burling-
ton Magazine*. The four hundred *écus* it was worth enabled Caravaggio to
settle his debts and live quite comfortably. It specified two paintings, as at

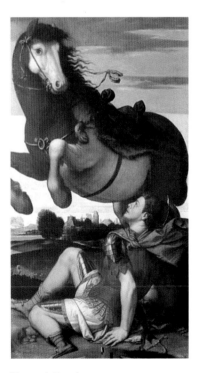

Moretto da Brescia
Conversion of Saint Paul (detail), 1529–1530
Milan, Santa Maria presso Santo Celso

San Luigi dei Francesi, though slightly smaller; they were originally to have been painted on cypress panel, but were finally executed on canvas. The subjects imposed by Cardinal Cerasi were the *Crucifixion of Saint Peter* (ill. p. 68) and *The Conversion of Saint Paul* (ill. p. 67). It is easy to imagine Caravaggio bridling at these very conventional subjects. Nevertheless, he set to work. Today, the paintings can still be seen (dimly lit) in Santa Maria del Popolo, amid the restaurants and cafes of fashionable Rome, just as they were hung by Caravaggio.

But things did not go smoothly. The first versions of both pictures were rejected outright. The first *Crucifixion of Saint Peter* is no doubt the one in the Hermitage (ill. p. 69), and the first *Vocation of Saint Paul* has disappeared. The second *Crucifixion* (ill. p. 68) was delivered late, and is so realistic that the Carmelites of Santa Maria were quite alarmed: the executioners are labouring to raise the heavy cross to which the Saint is nailed. The Saint himself was modelled by one of Caravaggio's usual models, who also appears in the San Luigi dei Francesi painting, and in the *Rest on the Flight into Egypt*. Berenson pitilessly describes it as "a study in how a heavy weight can be raised without a machine". After many doubts and hesitations, the work was accepted.

It is possible that two versions of its companion piece, the *Vocation of Saint Paul*, were rejected. But there was no question of Caravaggio reverting to a more decorous vision. As with the *Death of the Virgin*, his interpretation was intensely provocative. The horse occupies almost the entire space of the picture. A Prelate of Santa Maria is said to have asked in exasperation:

"Why have you put a horse in the middle, and Saint Paul on the ground?"

"Because!"

"Is the horse God?"

"No, but he stands in God's light."

The dialogue was noted by a Santa Maria cleric. Berenson too wonders about the importance accorded to the horse's cruppers: "Caravaggio," he writes, "prefigured the sculptors of the twentieth century, for whom the posterior is the most interesting thing. Their excuse is that it is the easiest part to render."

In Roberto Longhi's view, the two Santa Maria pictures testify to the full extent of Caravaggio's genius. "How far he has come, since his adolescent experiences with the mirror! Caravaggio has become a master of darkness, and what he lets us perceive through it cannot diminish his tragic, virile pessimism. He knows that for the *Crucifixion of Saint Peter* he can keep his distance from the display of terrifying brutality painted sixty years before by the other Michelangelo for the Pauline Chapel. That he need not emphasise the cruelty of the executioners, as he had at San Luigi dei Francesi. Everything proceeds unthinkingly, and everyone performs his task. The desolation resides purely and simply in the event… And the Saint, a good model well known in the via Margutta, already nailed to the cross, looks calmly on, fully conscious, a modern lay hero… In the *Vocation*, too, our painter merely smiles at what, eight or ten years previously, as an adolescent, he would have thought of this subject… Discreetly ironic about contemporary scholarship, he places in circulation what is perhaps the most revolutionary painting in the history of sacred art". Anthony Blunt

Georges de La Tour
Saint Joseph as Carpenter (detail)
Oil on canvas,
137 x 102 cm
Paris, Musée du Louvre

"Caravaggio and La Tour are intimately linked by their genius." (André Malraux)

PAGE 67:
The Conversion of Saint Paul, 1601
(second version, accepted)
Oil on canvas, 230 x 175 cm
Rome, right-hand wall of Cerasi Chapel in
Santa Maria del Popolo

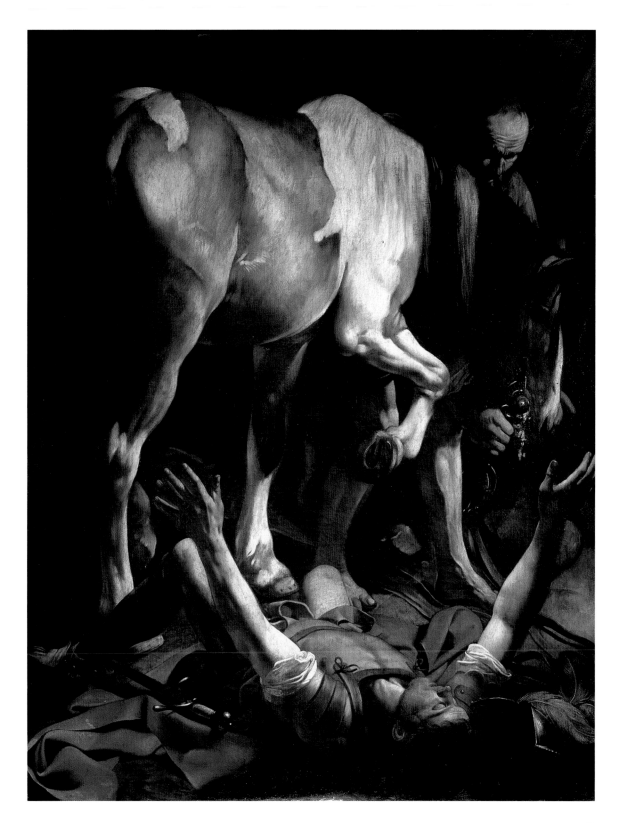

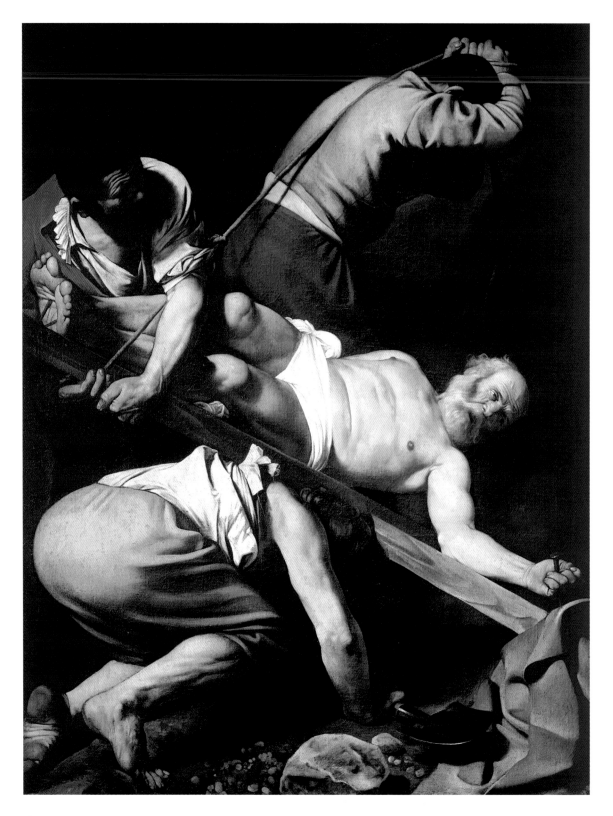

has recently demonstrated that the *Vocation of Saint Paul* inspired Georges de La Tour's *Saint Joseph as Carpenter* (ill. p. 66).

Caravaggio forfeited one hundred *écus* of his contract for late delivery. Hung very high, like the San Luigi paintings, those of Santa Maria del Popolo, vanished into the shadows of the church, and were forgotten until their "rediscovery". Caravaggio himself took umbrage at the criticisms, indeed insults, that greeted the works, and returned to his milieu in the underbelly of Rome. For several months we have no record of him. Accompanied by his friend Spada and a young stableboy named Benedetto, he wandered without direction. Valentin caught up with him and offered two subjects likely to please him: a *Narcissus* (ill. p. 33), whose attribution was confirmed only recently by radiography, and a *Victorious Cupid* (ill. p. 16) which was, to the great embarrassment of Valentin, deemed indecent. Love is generally represented in the form of a child. Here it takes the form of an adolescent – perhaps the stable hand Benedetto – trampling underfoot the symbols of knowledge and power. Within the painting, we read an inscription "Love conquers all". Marchese Giustiniani purchased the painting. Herman Voss had this to say about it: "In this figure, glittering with life and wonderfully painted, Caravaggio returned to his earliest themes… It is the more interesting, then, to note the new atmosphere of this work; it is much more immediate and suggestive in conception and much more unified in its colours and chiaroscuro. The 'Giustiniani' Cupid is inconceivable without the great history paintings that preceded it".

Victorious Cupid (also called *Profane Love* or *Love Triumphant*) was painted in 1603. We know this from a letter written by Orazio Gentileschi, father of Artemisia and friend of Caravaggio, in which he urges the return of a pair of wings that he had lent Caravaggio for this work. Of course, the painting raised uproar. It was rumoured to parody the famous statue *Victory*, by Michelangelo, now in the Palazzo Vecchio in Florence. It was suggested that it alluded to the Saint Bartholomew of the *Last Judgement* in the Sistine Chapel, and that Caravaggio had sought to "out" his great predecessor as a homosexual. Baglione, Caravaggio's rival, reacted by painting a *Divine Love*. The "indecent" painting at Giustiniani's house was veiled with a green cloth, which Petrarch, some twenty-five years later, insisted on raising to satisfy his curiosity.

These intensely productive years between 1602 and 1606 were also marked by a series of disreputable escapades, along with various crimes and brushes with justice. The semi-official publication *Avvisi* testifies to this. One Girolamo Spampa, who had been wounded with a dagger for adverting unfavourably to Caravaggio's San Luigi paintings, lodged a complaint. But no charges were laid. Soon afterwards, Caravaggio was accused of having written or commissioned sonnets defamatory of his enemy and future biographer, the painter Baglione, who had just painted a *Resurrected Christ* for the church of the Chiesa del Gesú. Caravaggio thought it very imperfect, and was arrested and incarcerated in the Tor di Nona prison for saying so. In Rome, critical judgements of this kind were no laughing matter. The minutes of the interrogation have survived; Caravaggio took the opportunity to express his thoughts about his colleagues, the painters of Rome. But he combined this profession of faith with a collection of contradictory remarks and non-sequiturs clearly intended to throw the investigators off the track. Thus he spoke highly of a number of painters, such as

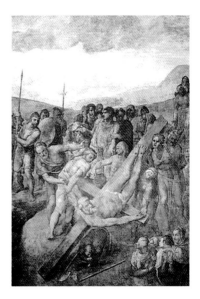

The Crucifixion of Saint Peter (copy?), c. 1600
Oil on canvas, 232 x 201 cm
Saint Petersburg, Hermitage

This is thought to be a copy of the first version of the *Crucifixion*, which was to hang opposite the *Conversion of Saint Paul*, but was refused by Cardinal Cerasi. The composition has affinities with those on the same subject by Rubens (Cologne) and by Guido Reni (Vatican Museum). Today the painting is considered to be a copy of the lost original, made by Caravaggio's friend Lionello Spada.

PAGE 68:
***The Crucifixion of Saint Peter*, 1601**
Oil on Canvas, 230 x 175 cm
Rome, left-hand wall of Cerasi Chapel in Santa Maria del Popolo

Saint Matthew and the Angel, 1602
Oil on canvas, 223 x 183 cm
Destroyed in 1945, during the fall of Berlin; it
formerly belonged to the Kaiser-Friedrich-
Museum, Gemäldegalerie, Berlin.

This first version was destroyed; the Saint was
considered too vulgar and the angel too famil-
iar.

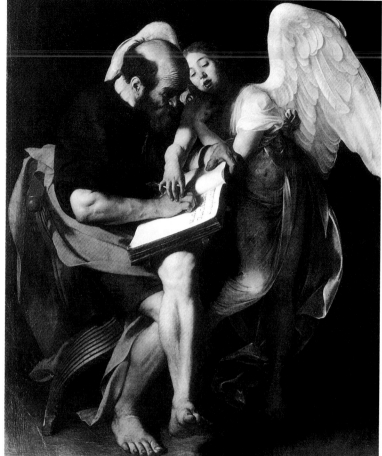

Detail of **Saint Matthew and the Angel**
(second version)

This time, the angel keeps his distance, and in-
stead of directly guiding the hand of the Evan-
gelist as he writes, he uses the language of
signs.

PAGE 71:
Saint Matthew and the Angel, 1602
Oil on canvas, 295 x 195 cm
Rome, altarpiece of the Contarelli Chapel of
San Luigi dei Francesi

The second version proved easier to accept:
the Saint had acquired noble features and a
halo, and the angel treats him with greater def-
erence. Caravaggio has, however, been criti-
cised for not knowing how to depict angels in
flight, and for painting them, instead, as acro-
bats.

Zuccari, whom he detested, and very ill of some of his best friends, such as
Orazio Gentileschi.

His testimony, full of impertinence, irrelevance, contradictions and lies
was not likely to move his judges to mercy, and he would have been sen-
tenced without the intervention of his patrons, the Marchese Giustiniani
and two or three cardinals. He promised to mend his ways and to apologise
to Baglione, and was released. For a while, we hear nothing of him. He fin-
ished a *David with the Head of Goliath* (ill. p. 78), and painted a second
three years later. And he accepted an interesting commission, a large
Madonna di Loreto, or *Madonna of the Pilgrims* (ill. p. 76; the Santa Casa
at Loreto, in the Italian Marches, was a famous pilgrimage resort) for the
Cavaletti Chapel of San Agostino.

He set to work, but the commission brought misfortune in its wake.
The model that he chose was a woman named Lena, who marketed her
charms in and around the Piazza Navona. One of her clients was the notary
Mariano Pasqualone. Did he object to the modelling sessions? Was Car-
avaggio suddenly struck with jealousy? Nobody knows. We *do* know that
Paqualone, blood streaming from his wound, took refuge with the Corte,
and declared that Caravaggio had "assassinated" him in front of the

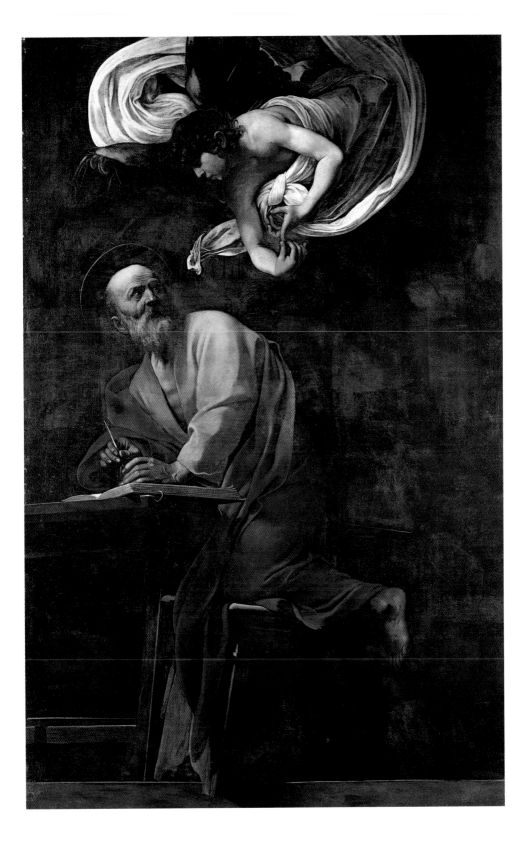

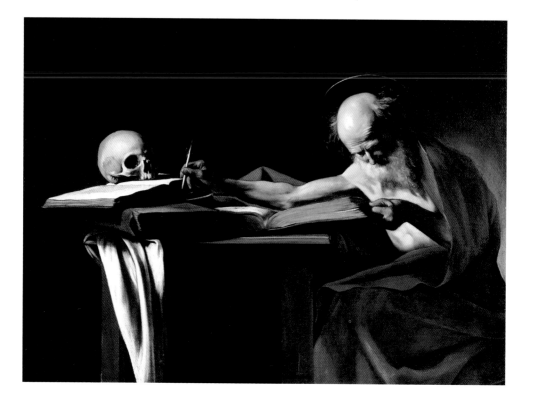

Saint Jerome Writing, c. 1606
Oil on canvas, 112 x 157 cm
Rome, Galleria Borghese

PAGE 73 TOP:
Detail of *The Death of the Virgin*

Palazzo of the Spanish Ambassador. The notary of the *Tribunale dei mal-efici,* the magistrate responsible for investigating serious cases, took the matter seriously. Caravaggio found it advisable to leave Rome. He went to Genoa, where he took refuge with the Prince Marzo Colonna, whose patronage had begun with Caravaggio's years of apprenticeship in Milan. All this was in 1604.

While in Genoa, Caravaggio was requested by Prince Marcantonio Doria to fresco the walls of his country house, and refused. Today, one can see in the Palazzo Bianco at Genoa a moving *Ecce Homo* (ill. p. 86) by Caravaggio, though there is nothing to suggest that he painted it during his stay there.

Pasqualone having mysteriously withdrawn his charges, Caravaggio returned to Rome and finished the astonishing *Madonna di Loreto.* She is traditionally portrayed in mid-air above the Santa Casa. Caravaggio chose to show her in a humble peasant dwelling, where she is receiving the fervent homage of two aged pilgrims with dirty feet. The Virgin's face expresses infinite tenderness, while the baby Jesus in her arms observes the old men with a mixture of anxiety and curiosity. The realism of the pilgrims' faces is striking – Baglione, indeed, judged it obscene.

As usual, the painting inspired praise and detraction in equal measure. The priests of San Agostino were reluctant either to accept or to pay for it. A letter from one of them has survived in the Modena State Archives, in which he inquires about Caravaggio's brushes with justice. And, to complicate matters, there was now a new "affair": during a hard-drinking dinner at the Albergo del Moro, Caravaggio considered himself ill-treated and hurled

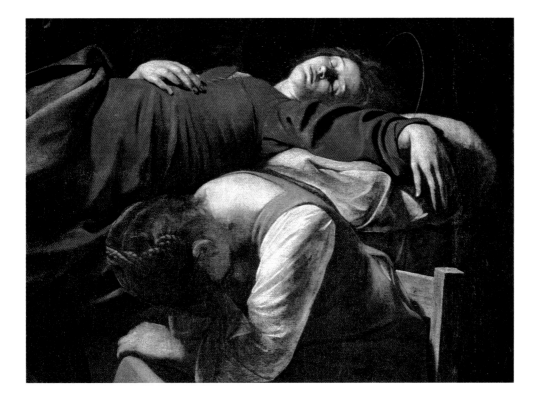

a plate of scalding artichokes in the face of a waiter, causing a fight which spread through the inn. The Corte again arrested the malefactor, and his patrons again obtained his liberation.

To earn his pardon, Caravaggio agreed to paint a *Saint Francis Meditating* for the Capuchin church, and a *Saint Jerome Writing* (ill. p. 72); the latter was a long-standing request, since Jerome enjoyed a particular vogue during the Counter-Reformation. The picture was long attributed to José Ribera; there is a second version in Montserrat, which may or may not be by Caravaggio. (The same model posed for both of these superlative paintings.) The light streams off the bald head of the Saint to fall on the *memento mori* with which it is equated; between them lie ancient tomes. White cloth hangs down from the table beneath the skull, while the Saint's arm stretches out as if to dip his quill. Caravaggio here is at the height of his powers, and the effect is dazzling. Longhi suggests that the *Christ on the Mount of Olives* (destroyed in Berlin in 1945 and known through copies) belongs to this period, along with the *Saint John the Baptist* of the Galleria Borghese (ill. p. 91), and the second *Supper at Emmaus,* that of the Pinacoteca di Brera, Milan. The latter was bought by Ottavio Costa, and is perhaps the most accomplished work of Caravaggio's Roman period. In the arrangement of the five figures, the use of light, and the gestures and expressions of the protagonists, Caravaggio attains to a kind of perfection. The bread and wine symbolize the Eucharist; Caravaggio has added a modest plate of salad, such as was served in the poorest inns. A earlier version of *The Supper at Emmaus*, painted some eight years before, is in the National Gallery in London (ill. p. 59): Christ is younger, the gestures of the

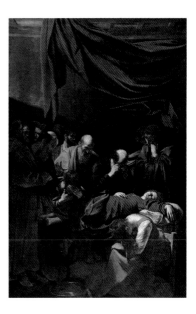

The Death of the Virgin, c. 1606
Oil on canvas, 369 x 245 cm
Paris, Musée du Louvre

It was rumoured in Rome that Caravaggio's model for the Virgin was a prostitute found drowned in the Tiber; a scandal ensued.

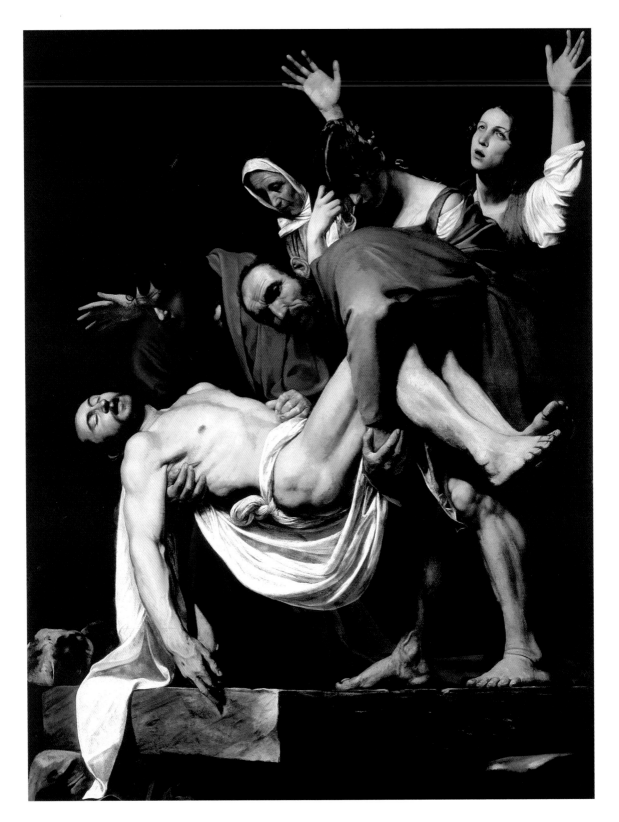

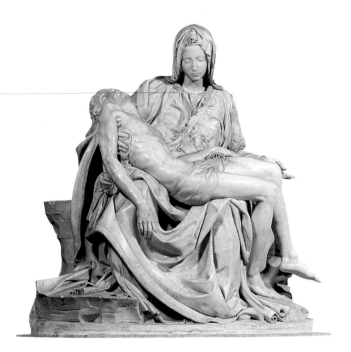 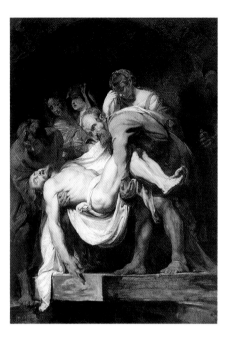

protagonists are more theatrical, and the spread on the table is comparatively luxurious. It is said to date from Caravaggio's arrival in Rome, when he was still full of energy.

The protection of Prince Colonna brought with it a flood of commissions, and Caravaggio's genius flowered under his new patron. Now came the ultimate accolade: Cardinal Scipione Borghese persuaded his uncle, Pope Paul V, that, despite his reputation, Caravaggio should be commissioned to paint a Virgin for Saint Peter's. To paint for the greatest church in Christendom was the dream of every Roman painter. The commission was for an altarpiece in the chapel that had just been handed over to the Confraternità dei Palafranieri, to which Paul V was greatly attached. The Cardinals of Saint Peter's reluctantly accepted, and Caravaggio received the commission. It was the chance of a lifetime.

Heedless of advice, Caravaggio again conscripted Lena, the model for the *Madonna di Loreto*, and painted the *Madonna dei Palafranieri* or *Madonna with Serpent* (ill. p. 77) in a matter of days, as he usually did. The result was a complete disaster. "Why," wrote Roberto Longhi, "was it precisely when appeal was being made to his sense of responsibility and his ambition that Caravaggio felt impelled to adopt the most brutal interpretation?… In fact, though he knew that the subject was linked to the liturgical symbol of the Immaculate Conception, the dominant tone of the work is strongly plebeian. Saint Anne is an old gypsy, the Virgin has her skirts rolled up like a washerwoman, and Christ is as naked as the day he was born… a robust family, truly, who stop on the threshold of the stable (of the Palafranieri, the Ostlers) to chase out an inoffensive viper… Why did he thus put everything at risk? For after all, the real patrons – not the Palafranieri but the Cardinals of Saint Peter's – could hardly accept this. Rejection was inevitable…"

With the rejection of the *Madonna dei Palafranieri*, also called

LEFT:
Michelangelo
Pietà, 1499
Marble, 174 cm high, with base 195 cm
Rome, The Vatican, Saint Peter's

RIGHT:
Peter Paul Rubens
Copy of Caravaggio's ***Entombment,***
1613–1615
Oil on panel, 88.3 x 65.4 cm
Ottawa, National Gallery of Canada

Caravaggio avoids the tragic and adopts the languid pose and serene countenance pioneered by Michelangelo, who, in the *Pietà,* gives the impression that the Christ is motherly cared for by the Virgin.

PAGE 74:
The Entombment, 1602–1603
Oil on canvas, 300 x 203 cm
Rome, Vatican City, Pinacoteca Vaticana

PAGE 76:
Madonna di Loreto or ***Madonna of the Pilgrims,*** 1604–1605
Oil on canvas, 260 x 150 cm
Rome, Sant'Agostino

PAGE 77:
Madonna dei Palafranieri or ***Madonna of the Serpent,*** 1605–1606
Oil on canvas, 292 x 211 cm
Rome, Galleria Borghese

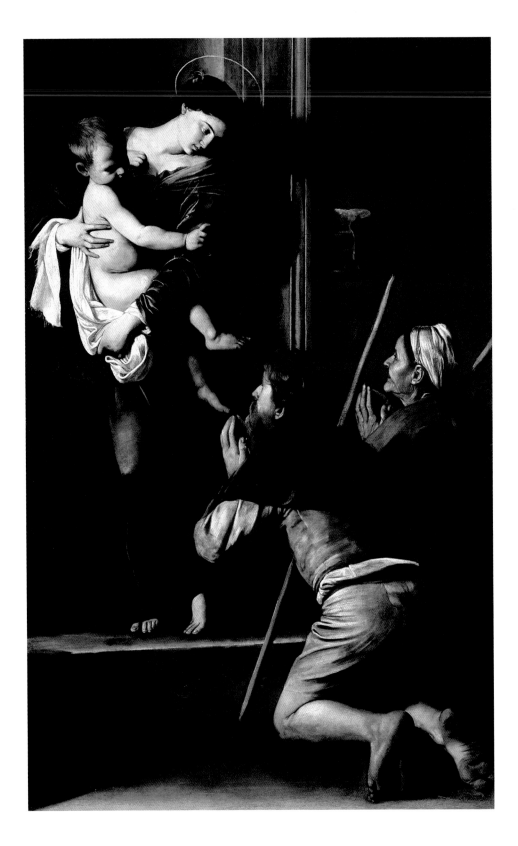

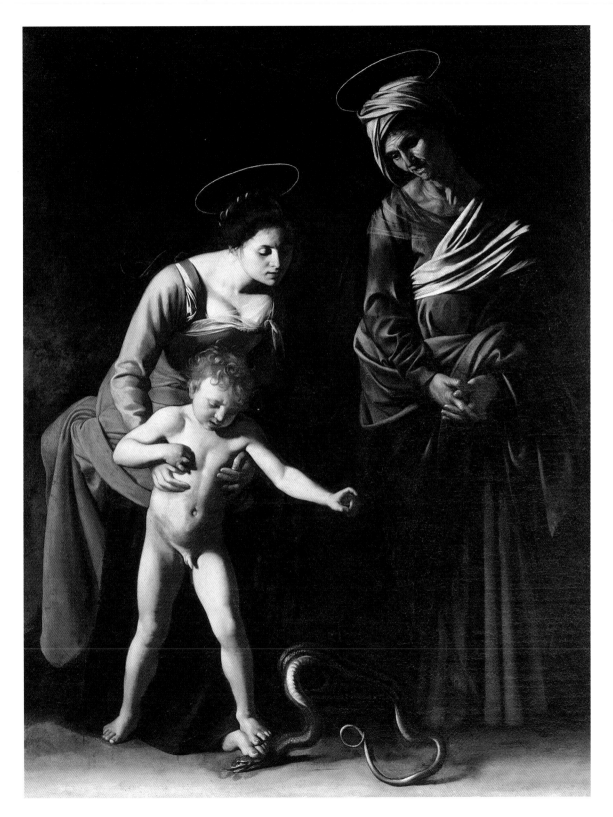

Madonna with Serpent (ill. p. 77), the doors of Saint Peter's were closed to Caravaggio, and with them, the ultimate official accolade. The secretary of the one of the cardinals wrote: "We find nothing in this picture but vulgarity, sacrilege, impiety and disgust. It would seem to be the work of a painter who knows his craft, but whose spirit lies in darkness, who has long been far removed from God and adoration of God, and from all good thoughts".

Where his rivals – Pomarancio, the Cavaliere d'Arpino, Passignano and even Baglione made steady progress in their careers, entered the Accademia di San Luca and received the Cross of Christ, Caravaggio never enjoyed such honours and rewards. Was this a matter of policy on his part? At all events, the opportunity never came again.

Scipione Borghese bought the *Madonna dei Palafranieri* for his own personal collection. It was the last work of Caravaggio's Roman period. He had reverted to his nocturnal escapades, and soon found himself again within the walls of the Tor di Nona prison. This time, it was not just a quarrel, but a murder; a Corte sergeant, who had been about to question him in the middle of the night, had had his skull smashed by a fierce blow. Caravaggio testified that a stone had fallen from the rooftops at that very instant… The Corte, despite the testimony of his friends, found this version incredible, and Caravaggio remained in prison. Indeed, he was interrogated with the full force of law: bound to the rack and lashed. It seems possible his *Flagellation of Christ* (ill. p. 87), painted at Naples, was inspired by memories of this event.

His friends feared for his life this time, and saw only one solution: escape. Two guards were bribed, with the complicity of Scipione Borghese, and Caravaggio was whisked away. But he was now on the "wanted" list and his friends were unable to have the charges withdrawn. Moreover, he had not learnt his lesson. In the port of Ripetta, on the banks of the Tiber, he was involved in a fight. A landlady named Prudencia, who had seized certain objects belonging to the painter, found her windows bombarded with stones one night. And the worst was still to come. On the Campo di Marzio, on 29 May 1606, during a game of royal tennis, he accused his opponent, Ranuccio Tommasoni de Terni, of cheating. The stakes were high, and there was a fight. Caravaggio always wore a dagger; daggers were drawn; Tommasoni received a fatal wound. Caravaggio too was wounded, but managed to escape. Longo and Spada were imprisoned. The *Avvisi* for Rome of 31 May 1606 announced that Michelangelo Merisi, a painter from Caravaggio, was condemned to death and "banished", which meant that any member of the Corte could at any time execute the sentence without further ado. Terrified, Caravaggio sought his protectors. But Scipione Borghese was travelling, Cardinal del Monte was ill, Marchese Giustiniani was out of Rome, as were Prince Colonna and the French Ambassador. Others among his patrons were weary of him.

He was forced to flee Rome, which he did by night and in disguise, setting out for Paliano in Latium, just outside the reach of Roman law, on Colonna land. He was weakened by his wound, and ill. Now he was back in the underworld, as he had been when he arrived in Rome, twelve years before. He was thirty-five, and a period of his life had come to an end. Rome had offered him, if not wealth, at least the means to express his genius. But there was more to come; he still wanted to paint. And paint he would. But he was never to return to Rome.

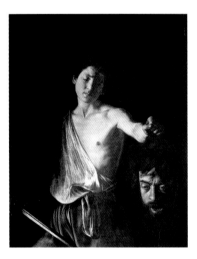

David with the Head of Goliath, 1605–1606
Oil on canvas, 125 x 100 cm
Rome, Galleria Borghese

PAGE 79:
Detail of ***David with the Head of Goliath***
This is a self-portrait; note, on the brow, the trace of the wound Caravaggio received in Naples. Life reflected in art: Caravaggio is both executioner and victim, the featherweight David and the ageing Goliath.

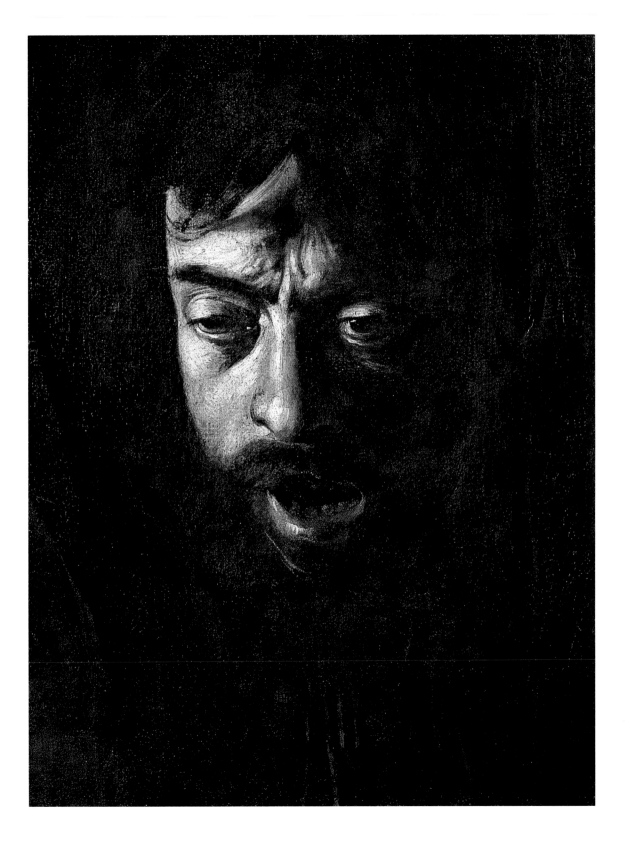

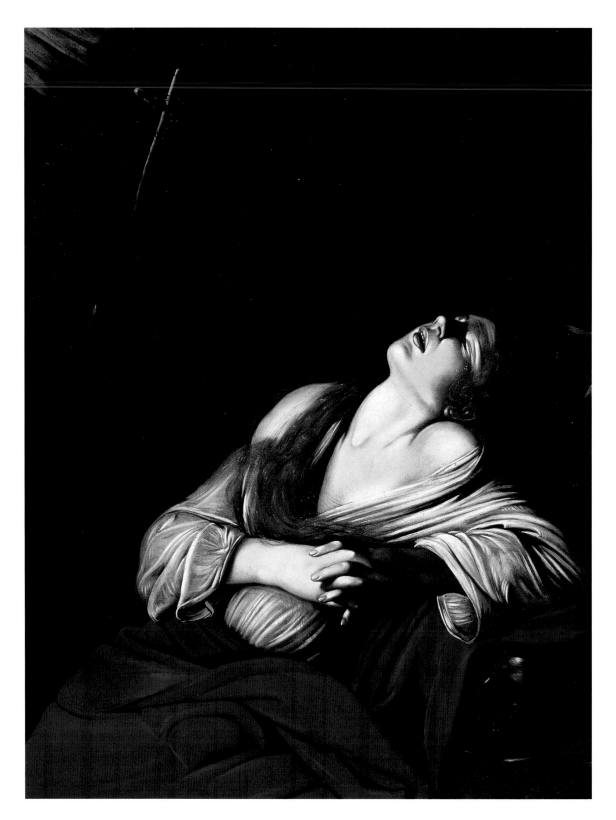

The Peregrine Years 1606–1610

When he fled the papal jurisdiction in May 1606, under an effective death sentence, Caravaggio was one of the most famous painters in Rome. In the absence of a papal pardon, he thought it wise to put a little more distance between himself and the Corte before the end of the year. He did not dwell long on the choice. Two or three days' travel away lay a great city, at the time one of the most populous in Europe: Naples, full of new artistic trends and ideas and the first rumblings of revolt. There he received a commission from a merchant of Ragusa, named Radulovic. This was *The Madonna of the Rosary* (ill. p. 82), a huge altarpiece (3.64 x 2.50 metres) painted for the Dominican church.

It marked the advent of a new and still more realistic style of painting, and, as usual, it caused a scandal. The Dominicans acknowledged its merit – its exceptional "models" and its eloquent play of light – but rejected it nonetheless. It was bought by the Bruges painter Finsonius, who sent it to Antwerp, where an association of artists, among them Rubens, Bruegel and Van Balen, bought it for the Dominican church in Antwerp; it cost them 1,800 florins. In 1781, the Austro-Hungarian Emperor Joseph II fell in love with it and persuaded the Dominicans to sell.

Fortunately, another commission came in its place, this time from the governors of the Pio Monte della Misericordia: a large altarpiece (3.9 x 2.6 metres) for the church of the Confraternity. They offered 470 ducats for a notably difficult subject, *The Seven Works of Mercy* (ill. p. 84). This was the first time a painter had depicted the seven corporal works of mercy listed by the evangelist Matthew (25, 35ff) in a single painting. Like the *Madonna of the Rosary*, it is a typically Neapolitan work in spirit, choice of models and treatment. The rich and the poor, the noble and the wretched, are represented in a nocturnal street. A woman of the people gives suck to an old man at the gates of the prison (5, 35: "For I was an hungered, and ye gave me meat"). A gentleman unsheathes his sword to divide his cloak with a naked beggar. An inn-keeper gives a drink to a man "athirst", who, like Samson, makes use of the jaw-bone of an ass. Another man welcomes exhausted pilgrims arriving in their travellers' cloaks. The last work of mercy, that of burying the dead, is illustrated by the feet (and nothing but the feet) of a corpse, on which a ray of light falls.

Jullian sees in the *Seven Works of Mercy* "the last fulguration of the Caravaggesque baroque"; Berenson, who dislikes it, judges the subject "all but grotesque". For Longhi it is a masterpiece, whose influence was felt by Rembrandt, Hals and Velázquez. Ribera borrowed the inn-keeper who, on

Simon Vouet
Saint Mary Magdalene in Ecstasy, c. 1630
Oil on canvas, 100 x 80 cm
Besançon, Musée des Beaux-Arts

With his *Saint Mary Magdalene in Ecstasy*, Caravaggio created a new image of the penitent, discarding the traditional representation of sainthood in order to depict the invisible. Instead of showing Magadalene crushed under the burden of sin, he shows her already converted and plunged in divine contemplation, as expressed by her furrowed brow, upturned eyes, protruding lower lip and clenched fingers. This image influenced many artists, notably Orazio Gentileschi, Bernini and Simon Vouet.

PAGE 80:
Saint Mary Magdalene in Ecstasy (copy?), 1606
Oil on canvas, 106.5 x 91 cm
Marseille, Musée des Beaux-Arts

This picture was a resounding success, and many of the copies made at the time have since found their way into museums. But which is the original?

the left of the painting, welcomes the pilgrims, for one of his *Allegories of the Five Senses*.

During his first stay in Naples, which lasted some eight months, Caravaggio painted two *Flagellations*, as if recalling his own experience of torture in Rome. "The darkness," writes Mina Gregori on the one in Naples (ill. p. 87), "brings out the internalised strength of Christ". Roberto Longhi considers the work one of the most heart-rending of Caravaggio's corpus: "Infinite devotion struggles with infinite brutality", he observes, "in a dramatic struggle such as we find in Rembrandt some thirty years later". In the smaller *Flagellation* (Musée des Beaux-Arts, Rouen), the same torturers are represented; Caravaggio was clearly settling personal scores.

In a matter of a month, the outlaw had become the most famous and productive painter in Naples. Now he suddenly left for Malta. Why? We can only conjecture. Had he, as some have suggested, been alerted to the arrival of envoys of the papal police, and left in fear of his life? A more probable motive is his desire to become a Knight of Grace of the Order of Malta (born a commoner, he could not aspire to the Knighthood of Justice). This would have allowed him to wear a sword; he no doubt thought it would assist his claim to a pardon. In July 1607, Caravaggio disembarked in Valetta, capital of the Knights of Saint John of Jerusalem, who defended the Christian Mediterranean against the Islamic Orient and the redoubtable Barbary pirates.

Caravaggio's Malta period is a disconcerting one; though he spent only five months there, he painted in quick succession a series of devotional and profane works so different one from another that specialists long attributed them to other periods of his life.

No sooner had he arrived than, thanks to Malaspina, he was commissioned to paint a *Saint Jerome Writing* for the Italian Chapel in the Cathedral of Valetta, Saint John. The painting pleased the Grand Master of the Order, a Frenchman elected to that position for life, Alof de Wignacourt; he commissioned a huge *The Execution of Saint John the Baptist* (5.20 x 3.61 metres, pp. 86–87). The Wignacourt arms appear on the original frame.

The renown of the painting was almost instantaneous. In later years, northern European painters would travel to Valetta to see it. The dark echoing spaces of the prison scene are desolation itself. We seem to witness the death throes of the martyr; he lies on the ground, his hands bound behind his back. The executioner prepares to detach the head with his dagger, while Salome holds the charger on which the jailer orders the head to be placed. An old woman, reminiscent of the serving women in the Brera *Supper at Emmaus*, recoils in horror. Two prisoners witness the execution from a barred window. Pietro Ambrogiani writes "One cannot help thinking that the painter was inspired by his own experience".

The Execution of Saint John the Baptist is the only canvas signed by Caravaggio. His name is written in the blood that spurts from the neck, indicating, it has been said, his identification with the victim. His name is preceded by the letter *F* for *Fra*, which means that, by the time the painting was complete, he had been made a Knight of Grace.

The Grand Master followed his first commission with a second: a portrait (*Portrait of Alof de Wignacourt*, ill. p. 88). Caravaggio happily

The Madonna of the Rosary, 1607
Oil on canvas, 364.5 x 249.5 cm
Vienna, Kunsthistorisches Museum, Gemäldegalerie

PAGE 83:
Detail of the hands of the ***Madonna of the Rosary***

Hands play an important role in all Caravaggio's paintings; there is a language of the hand in his paintings, which is also found among his illustrious descendents, in particular Velázquez and Georges de La Tour (cf. ill. p. 94).

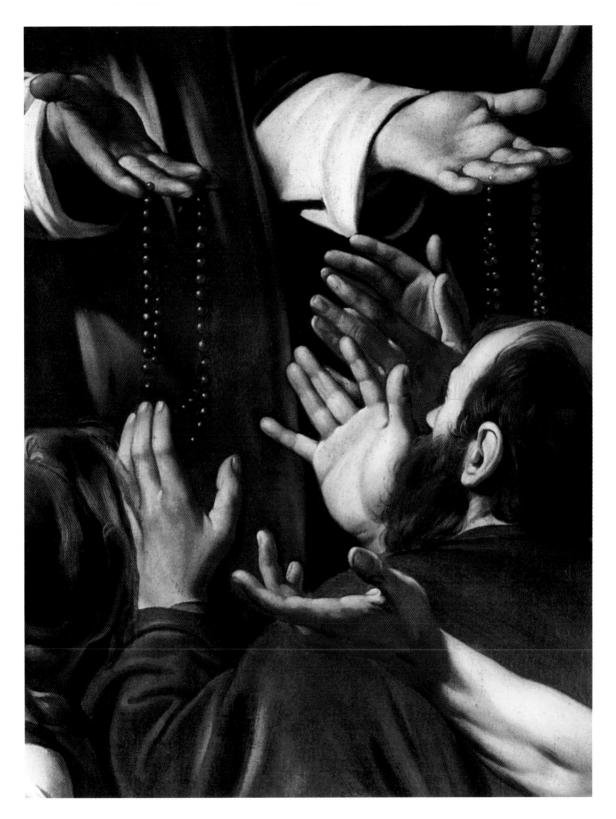

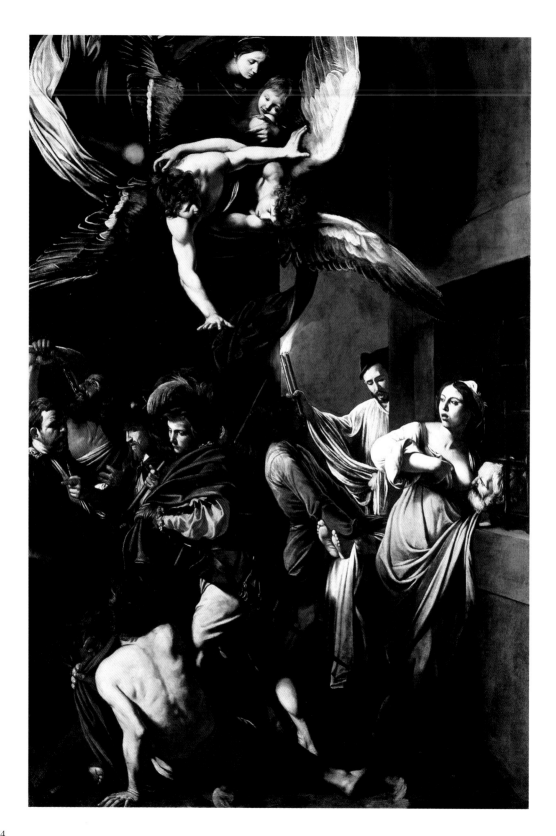

obliged, but fell victim to his old obsessions; beside the redoubtable warrior in his archaic armour, he placed an excessively handsome page carrying the Master's helmet. This was more than just a novelty in the world of the celibate knights, and the page, with his provocative glance, became as famous as his Master. Delacroix copied him into his sketch-book; Manet recalled him in his *Child with Sword* (New York, Metropolitan Museum of Art). The picture was bought by Louis XIV in 1670 for 1,400 *livres*.

Of course, scandal erupted. At the same time, it seems, he executed a *Sleeping Cupid* (ill. p. 90) reminiscent of the naked child in the *Madonna dei Palafranieri*, though less brazen; a shadow masks the sex of the child. On the reverse of the painting is the inscription: "opera di [work by] M.M. de Caravaggio, Malta, 1608".

The *Sleeping Cupid* was wholly at odds with the spirit of the Knights, and did not help matters when the newly appointed Knight of Grace was arrested and consigned to the prison of Sant'Angelo. No article of accusation has been found in the archives of the Order, and hypotheses are not lacking.

Hostile historians, little better than novelists, have imagined that Fra Michelangelo attempted to seduce the young son of a magistrat or a minister of the Order. It is also possible that Caravaggio had not informed the Knights of the Corte's sentence, and that they were horrified to discover it. Perhaps, again, he was the victim of a plot hatched by hospitallers enraged by his *Sleeping Cupid*.

At all events, he was expelled from the Order. The document designating him *putridum et foetidum* ["corrupt and stinking"] and liable to the full force of law, was found some years ago. This was no idle threat; the Order was notoriously severe in such cases.

Caravaggio was again forced to flee; he made a perilous escape from Sant'Angelo and took ship for Sicily. He landed at Syracuse, where he painted the *Burial of Santa Lucy* as an altarpiece for the church of Santa Lucia in Syracuse, which stands by the shore on the site where the saint was martyred; it was his first Sicilian commission. The painting was in very bad condition when "rediscovered" by the Frenchman Rouchès in 1920.

With this composition, Caravaggio introduced a new relationship between figures and space. Its novelty was unwelcome in Syracuse. The background wall occupies a large part of the painting, and the grave-diggers in the foreground, enormous relative to the other figures, seem weighed down by the décor. Berenson deems the work "cynical in the incongruity it displays, placing the mourners in the background, and giving excessive importance to the material aspect of things".

The hostile reception meted out to the *Burial* led Caravaggio to move to Messina. He received a warm welcome, and was quickly commissioned by the Confraternità dei Crociferi to paint a *Resurrection of Lazarus* (now in the Museo Nazionale, Messina). In it, Caravaggio gave free rein to his anguish, doubts and hope. Lazarus is shown without the traditional winding-cloth, scandalously naked, a true corpse; one of the company holds his nose at the stench. In a further blow to convention, Lazarus rises not from an ancient sepulchre, but a flagstone tomb of "modern" kind.

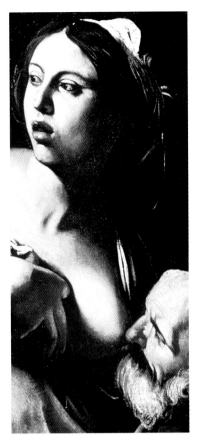

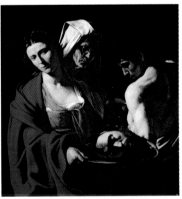

Salome, c. 1609–1610
Oil on canvas, 116 x 140 cm
Madrid, Palacio Real

TOP:
"I was thirsty, and ye gave me drink": detail of the *Seven Works of Mercy*

PAGE 84:
The Seven Works of Mercy, 1606
Oil on canvas, 390 x 260 cm
Naples, Pio Monte della Misericordia

RIGHT:
The Execution of Saint John the Baptist,
1608
Oil on canvas, 361 x 520 cm
Valetta (Malta), Oratory of the Cathedral of
Saint John

This is the only canvas signed by Caravaggio,
and became famous almost immediately it was
hung; people came from all over Europe to see
it. Today, it is considered the first great modern
tragedy in painting.

PAGE 87 ABOVE:
The Flagellation of Christ, 1607
Oil on canvas, 286 x 213 cm
Naples, Museo e Gallerie Nazionale di
Capodimonte

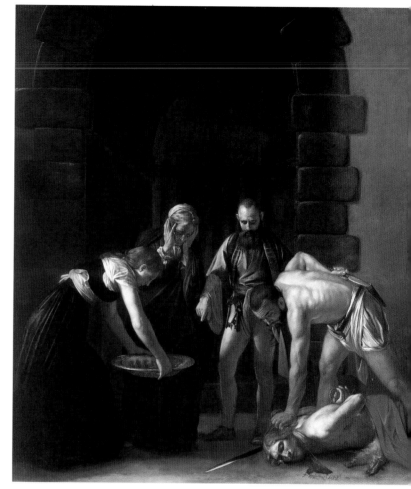

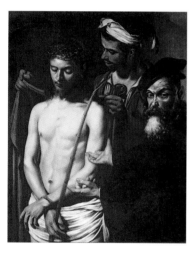

ABOVE:
Ecce Homo, 1605
Oil on canvas, 128 x 103 cm
Genoa, Galleria Municipale, Palazzo Rosso

PAGE 87 BELOW:
Sebastiano del Piombo
Flagellation, 1524–1525
Oil on plaster
Rome, San Pietro di Montorio

Caravaggio was inspired by del Piombo's
Flagellation. He reduced the protagonists to
the bare minimum, eliminated the architecture,
and "spotlit" the Christ, whose muscularity is
reminiscent of the athletes Michelangelo had
painted for the Sixtine ceiling.

According to certain commentators, it was during his stay in
Messina, in 1608, that Caravaggio painted the *Ecce Homo* (ill. p. 86) of
the Palazzo Rosso in Genoa. This was rediscovered in 1953 by Caterina
Marcenario, the Director of Fine Arts, during an inventory of the mu-
seum's reserves. Before the war, it was thought to be a copy by Lionello
Spada; it hung in the staircase of the nautical school at Genoa, and disap-
peared during the bombing of 1944. Long considered lost, it had in fact
been transported to the Palazzo Ducale, the city museum, where it lay
forgotten.

Caravaggio spent only a year in Sicily. In late 1609, he took ship at
Palermo for Naples, hoping soon to return to Rome. Marked by his ordeals,
aged (as the last self-portrait shows) and ill, he had lost neither his will to
live nor his desire to paint. The various works that he rapidly executed in
Naples give clear and tragic proof of this. For he never returned to Rome;
he had but a year to live.

In Naples, he was attacked, wounded, and left for dead in the street.
We know that the murder attempt really occurred, though the motive is ob-

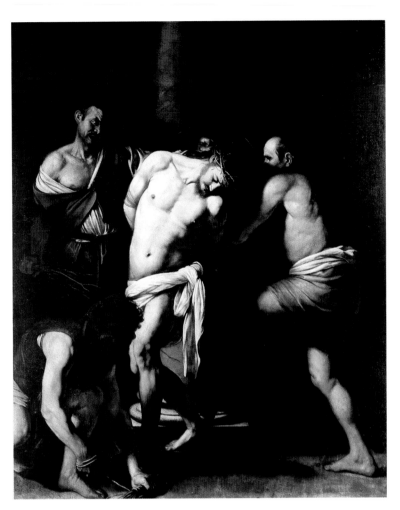

scure; Baglione speaks of a vendetta. Longhi blames the ambush on envoys
from Valetta; Caravaggio's survival is said to have been little short of
miraculous, and to have left him with a scarred face.

Whether Caravaggio painted or began other works during the year
1610 we do not know, and probably never shall. Two paintings have sur-
vived. The first is the *Saint John the Baptist* (ill. p. 91). The expression of
profound sadness and the pouchy eyes comprise elements of self-portrait,
as if in painful retrospect. "The turbulent and dramatic lighting here
reaches new intensity, as if it were the artist's last, feral lament," wrote
Roberto Longhi.

This *Saint John* contrasts with earlier ones, those of Kansas City, the
Corsini collection, and the *Saint John the Baptist at the Spring* in Rome; he
is clearly in bad health, painfully thin and with swollen joints. The curious
pose suggests disease, or, at very least, discomfort. Venturi observed: "This
is a man who has lived too long".

The *David with the Head of Goliath* of the Galleria Borghese (ill.
p. 78) offers in the head of the giant a last and painful self-portrait; it was

probably painted at this time. The artist had already depicted the scene, but never in this fashion. David is not triumphant but dejected; he contemplates in his victim a symbol of the vanity of earthly power. The scarred, haggard head of Goliath with its vacant gaze speaks of the painter's profound anxiety. David's sword (Italian: *spada*), which can be seen in several of Caravaggio's painting, perhaps evokes the presence of his faithful friend Lionella Spada.

Of these last works, one remains to be discussed: the *Martyrdom of Saint Ursula* (ill. p. 90), a work measuring 1.7 x 1.45 metres painted for the Genovese Prince Marcantonio Doria, the son of the Doge Agostino. It was the last commission accepted by Caravaggio, who was hoping to set aside some money for his return to Rome. In no other picture by Caravaggio is death so strongly present. Under our gaze, the arrow shoots from the extended bow of the Hun king to pierce the resigned breast of the saint.

"Within the limited space," writes Mina Gregori, "an imperceptible pause, an instant so short as to be negligible, elapses between the archer's gesture and the moment when the arrow has already penetrated the martyr's breast. Here too, in the quest for this instant, the painter denies history. And the darkness in which his ghosts are wreathed is also a negation of history and social hierarchy… We are permitted to ask whether this is not the source of the irresistible attraction that Caravaggio exerts to this very day".

After this poignant martyrdom, Caravaggio never painted again. The summer of 1610 was at its height. Shortly after finishing the painting, he decided to leave Naples.

Until recently, we had no record at all of the last days of Caravaggio at Naples. Instead of travelling to Rome by road, he went on board a felucca; this seemed to him safer. He would wait for the news of his long awaited pardon outside the papal jurisdiction. He took with him a few belongings and one or two paintings, and set sail for a port occupied by the Spanish, not far from the mouth of the Tiber: Porte Ercole.

By disembarking on this insalubrious, malaria-ridden coast, Caravaggio placed himself only a day's ride from Rome. The news of his pardon, if it came, would reach him quickly.

What happened? Were the Spaniards tipped off about his arrival? If so, was he denounced by the Knights of Saint John? He had no sooner come ashore than he was imprisoned in the citadel of Porto Ercole, and his luggage seized. His protests were unavailing; he vainly claimed to be a Knight of Saint John.

We do not know how he regained his freedom, but he had with him the money from his last commission, the *Saint Ursula*, and could therefore provide bail. He recovered at least part of his belongings. Presumably he attempted to reach an inn, or at least a shelter for the night, by walking along the beach. One account has him haggard, hungry, ill and worn out, looking for the felucca he had hired, or for another boat. His wounds, it is said, had become infected and brought fever in their wake. In another account, he entrusted himself to prowlers on the beach and was assassinated. His body was found on the beach, some distance from the citadel, whose imposing ruins still look out over the little harbour. He died, looking towards Rome, in July 1610.

Titian
The Allocution of Alfonso d'Avalos, c. 1541
Oil on canvas, 223 x 165 cm
Madrid, Museo del Prado

Caravaggio borrowed from Titian the figure in glinting armour on a dark background and the young page carrying his master's helmet. But Caravaggio's page has an impudent and equivocal gaze. The work earned Caravaggio the title of knight, but his relationship with the page, or rather the page's model, earned him a prison-sentence, forcing him yet again to take flight.

PAGE 88:
Portrait of Alof de Wignacourt, c. 1608
Oil on canvas, 195 x 134 cm
Musée du Louvre, Paris

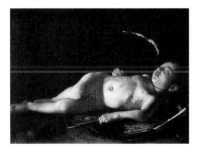

Sleeping Cupid, 1608
Oil on canvas, 72 x 105 cm
Florence, Galleria Palatina, Palazzo Pitti

BELOW:
The Martyrdom of Saint Ursula (detail), 1610
Oil on canvas, 154 x 178 cm
Naples, Banca Commerciale Italiana
Caravaggio's last picture; it is as if, in the image of the arrow and the spurting blood, he had sought to represent his own imminent death.

PAGE 91:
Saint John the Baptist, c. 1609–1610
Oil on canvas, 159 x 124 cm. Rome, Galleria Borghese
Infinite sadness finds expression in this, Caravaggio's penultimate painting, as though here too he already had painted a presentiment of his own death.

In August, the Roman *Avvisi* published the news of his death. Since his flight to Naples, his reputation had grown ever greater, but Baglione, his first biographer, stated: "His death, like his life, was disgraceful". His estate, the belongings that the Spanish had seized or recovered, was offered to the Knights of Saint John, who refused it. It comprised two paintings, perhaps the last *Saint John the Baptist* (ill. p. 91) and his *Salome* (ill. p. 85); we cannot be certain. The estate thus fell to the Viceroy of Naples, and we do not know what became of it.

Within days of the incident at Porte Ercole, Pope Paul VI was won over by Caravaggio's friends and granted the long-awaited pardon.

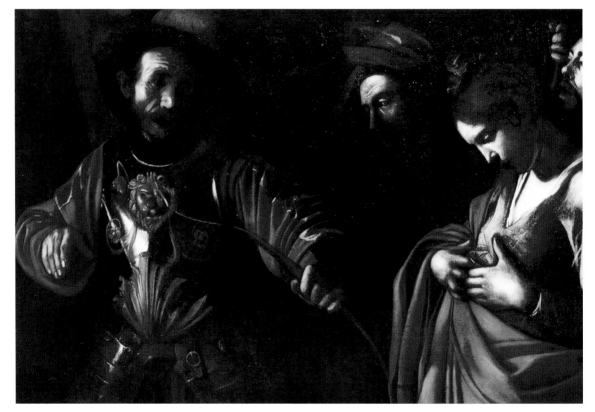

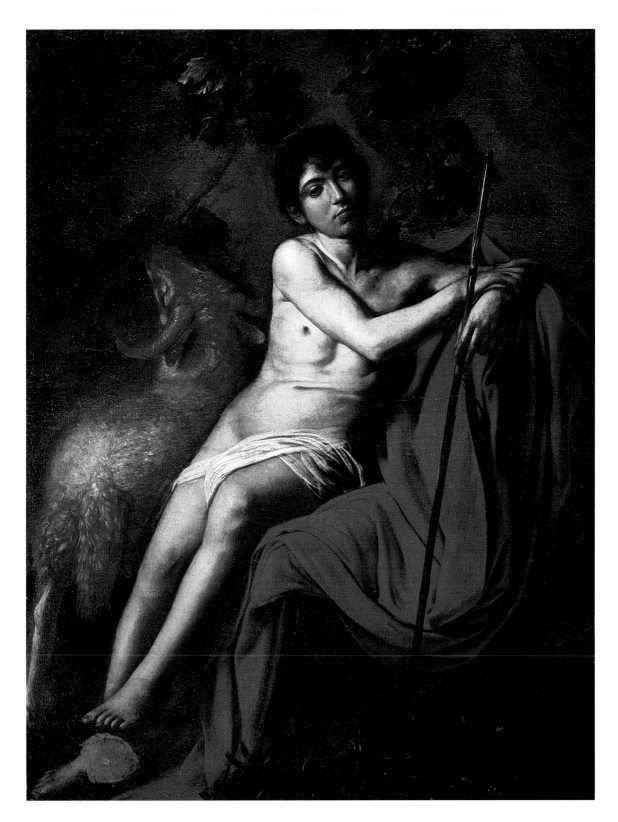

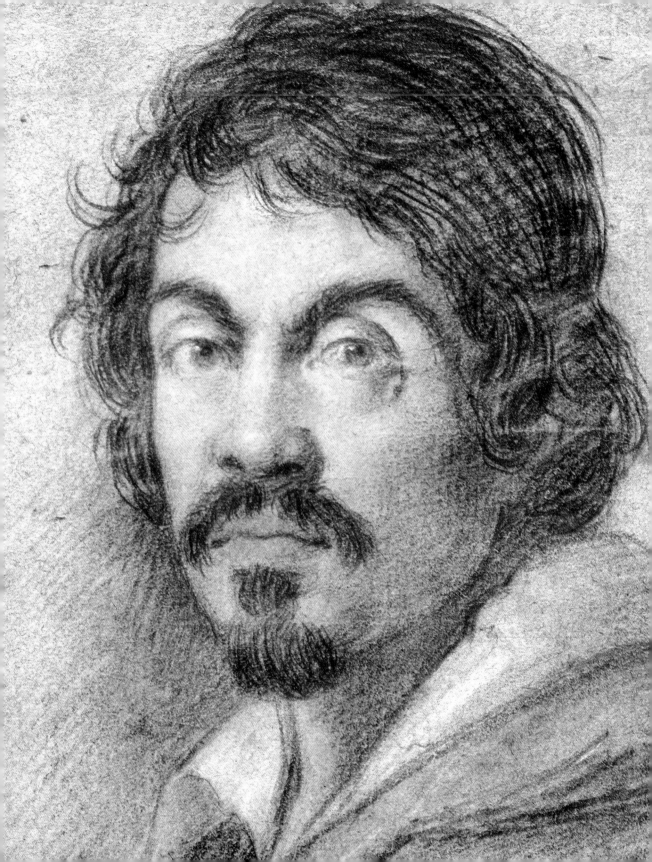

Life and Work

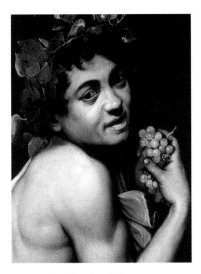

Self-Portrait as *Bacchus,* 1591

1571–1584 Michelangelo Merisi born 29 September 1571 in Caravaggio, a little market town in Bergamo, or perhaps in Milan. His mother, Lucia Aratori, is the second wife of Fermo, *magister* (architect-decorator and site overseer) to Franceso Sforza I, Marchese di Caravaggio. His brother Battista, who became a priest, is born a year later. Early childhood in Milan. Plague drives his family back to Caravaggio, where it claims his father and uncle. 1583: death of the Marchese di Caravaggio. Costanza Colonna inherits the Marquisate. Caravaggio's family suffers extreme poverty. 1576: death of Titian. 1581: Domenichino born. 1584: Frans Hals born.

1584–1595 At thirteen, Caravaggio returns to Milan and enters the studio of Simone Peterzano, an established painter and "pupil of Titian". The contract is approved by Prince Colonna. Peterzano, like the Campi brothers, is attracted to a more realistic style at odds with the prevailing Mannerism. A new style is born in Lombardy, whose influence the young apprentice feels. The great period of Renaissance painting is at an end. Pope Sixtus V is open to new trends in art. 1593: Georges de La Tour born. 1594: Nicolas Poussin born.

1595–1598 Caravaggio, having acquired exceptional technical facility in

Self-Portrait from *The Martyrdom of Saint Matthew,* 1598–1600

Peterzano's studio, leaves for Rome, the cultural capital of the world. His itinerary is not known, but he no doubt sees Masaccio's frescoes, Lotto's paintings, the works of the great Venetians, such as Giorgione, and the frescoes of Niccolò dell'Ab-

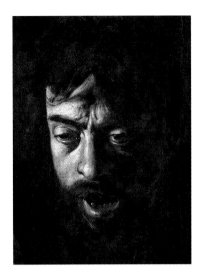

Self-Portrait from *David with the Head of Goliath,* 1605–1606

bate at Bologna. He also sees the drawings of Sofonisba Anguisciola at Cremona. He is given lodging by a Cardinal of doubtful morals. First works, all profane: *Boy Bitten by a Lizard, Boy Peeling Fruit, Boy with a Vase of Roses,* and the *Concert,* also called *The Musicians,* which includes a first self-portrait. Falls ill, recovers miraculously, and in his convalescence paints the *Ill Bacchus,* a second self-portrait. Acquires a powerful patron, Cardinal del Monte. He paints a woman for the first time, the *Repentant Magdalene,* followed by a *Fortune Teller,* and a second *Bacchus* in better health than the first. Has his first brushes with justice. Paints the famous *Basket of Fruit* (now in Milan).

1598–1600 Religious subjects: the *Sacrifice of Isaac, The Ecstasy of Saint Francis,* and others. 1598: Zurburán born. 1599: Velázquez born. 1600: Claude Lorrain born.

1600–1604 Two great commissions in which Caravaggio's powers are revealed: San Luigi dei Francesi (the *Vocation* and *Martyrdom of Saint Matthew*) and Santa Maria del Popolo (the *Crucifixion of Saint Peter* and the *Vocation of Saint Paul*). Both are highly controversial, as is *The Death of the Virgin* (Louvre), modelled by a prostitute. A *Madonna* for Saint Peter's is refused. Caravaggio wounds a lawyer in a fight over a prostitute, and flees to Genoa. Major religious paintings. In April 1604, a mêlée at the Albergo del Moro caused by Caravaggio. He is accused of murdering a police sergeant. Arrested and tortured, he is helped to escape.

1605–1607 *Madonna di Loreto*. 29 May 1606 (the police report has survived), Caravaggio kills one Tommasoni after accusing him of cheating at royal tennis. Wanted for murder, he escapes from Rome in disguise. He is banished: any representative of the law may kill him on the spot. Finds refuge in the territory of Prince Colonna. Late in 1606, goes to Naples. Welcomed there, he paints a *Resurrec-*

tion, a *Flagellation*, the *Seven Works of Mercy* and the *Madonna of the Rosary*; the latter alienates the Dominicans. He is an object of adulation. But the Pope's pardon is slow to come. Leaves Naples for Malta. 1606: Rembrandt born.

1607–1608 He wants to become a knight, believing this will facilitate his pardon. In Malta, paints major works for Valetta Cathedral and two? portraits of the Master of the Order. He is made a Knight of Saint John. But a further indiscretion lands him in prison, he is expelled from the Order, and is again forced to flee.

1608–1609 He disembarks in Syracuse (Sicily), and goes to Messina and Palermo. In the despair of exile, racked with illness, he paints intensely moving works: a *Resurrection of Lazarus,* a *Nativity*, and an *Ecce Homo*. In late 1609, he decides to return to Naples. 1609: A. Carracci dies.

1609–1610 Still awaiting a papal pardon, he paints a *Denial of Saint Peter*, and a *David with the Head of Go-*

liath, which includes his final self-portrait. This second Naples period was one of superlative works, including a last *Saint John the Baptist,* and a *Martyrdom of Saint Ursula* in which death is depicted, as if Caravaggio knew that he was doomed. An attempt on his life. News of his death spreads; in fact, he has left Naples, though wounded. He disembarks near Rome, at Porto Ercole, then occupied by the Spanish army. His body is found on the beach. He was not yet forty.

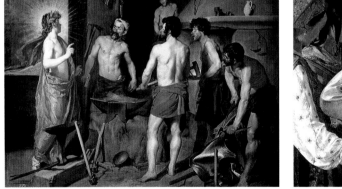

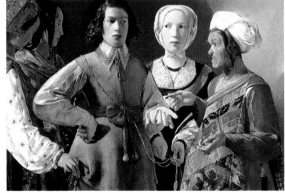

LEFT: Velázquez:
The Forge of Vulcan, 1630, oil on canvas, 222 x 290 cm, Madrid, Museo del Prado.

RIGHT: Georges de La Tour: **The Fortune Teller**, c. 1634–1635, oil on canvas, 102 x 123 cm, New York, The Metropolitan Museum of Art

PAGE 95:
Detail of the vase from
Boy Bitten by a Lizard (ill. p. 18)